Designed by Grace Sullivan, Catskill Press
Color correction by Dave Harrington, Ruder Finn Printing Services

Printed by Ruder Finn Printing Services

First published in 2004 in the United States by
Catskill Press, an imprint of Ruder Finn Press, Inc.
301 East Fifty-Seventh Street
New York, NY 10022

ISBN #: 0-9720119-6-X

Printed in the United States of America

Secret Stories
in the Art
of the Northwest Indian

Acknowledgments

Peter and Sarah Finn of the Catskill Mountain Foundation have, over the past five years, changed the cultural landscape and created a new community in the northern Catskill Mountains—the area surrounding the towns of Hunter, Windham, Jewett and Lexington. They have motivated artists and writers through exhibits and public presentations. They have produced concerts featuring local and world-class musicians, singers and dancers. They opened a bookstore and a movie house showing first-run domestic and foreign films. Of equal importance, they put together a group of sponsors to support their endeavors and to fund related ones.

Most recently, they decided to create a new publishing house—The Catskill Press—featuring the work of local artisans and writers. About a year ago, they came over to my studio to see my work and had me tell them the stories imbedded in every piece. To my total surprise, they then said: "We would like you to put all this into a large, colorful book." They encouraged me in the writing, and Pam Weisberg provided able advice and assistance. They brought me through it and produced a wonderful book which not only shows the work and tells the stories but captures its spirit.

I wish to thank the Catskill Press team for their assistance: Sarah Taft for her editing and Grace Sullivan for her graphic layout. My son Paul gave the book the continual oversight necessary to keep an endeavor like this on track. And my wife, Kopper, deserves all the credit for getting me to retire early and pursue my passion for carving and storytelling.

Finally, I wish to thank my Indian colleagues, particularly Chief Roy Crazy Horse of the Powhatan Renape Nation at the Rankokus Reservation near Camden, NJ, for exhibiting my work and allowing me to tell the stories and history of the Northwest Indian to the thousands of visitors to his annual art shows.

Oscar Newman (Bounding Warrior)
Windham, NY
October 2003

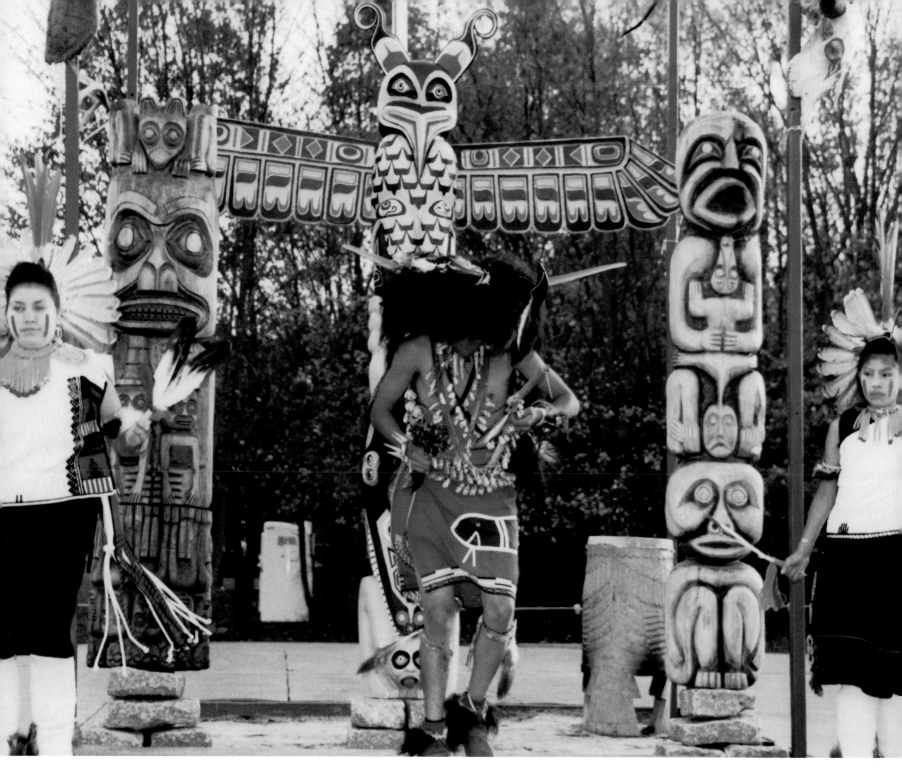

Three Bounding Warrior Totems at Indian Art Festival

Three totems by Bounding Warrior formed the on-stage centerpiece for all the ceremonies and presentations at the Indian Art Festival at the Rankokus Reservation in New Jersey in October 1998. From left to right the totems are called: Reflection on Generations; Thunderbird and Killer Whale, and the Possum Clan, Speaker's House Post. The Mushiwi Dancers are seen performing in the foreground.

Contents

Illustrations

Front Cover: Reflection on Generations

Table of Contents: Three Bounding Warrior Totems at Indian Art Festival

Historical Photographs

Secrets Revealed

I: Totem Poles

Preface

At age 60, I decided to put aside my architectural and city planning practice and devote my remaining physically active years to the art of my ancestors. My family, descendants of Russian fur traders and Northwest Indians, had been collecting the artifacts and legends of the Northwest Indian for generations, and I grew up among them. They enthralled me, both as a child and as an adult. Their myths helped frame my initial understanding of the world, just as their art structured my early conceptions of form.

Over the past ten years, I have been carving totem poles, making masks and painting murals that illustrate the myths of the Northwest Indian. And I have chosen to do so in the Catskill Mountains of New York, first because they reminded me of the coastal ranges of the Northwest and second because the family I had raised in New York City had come to adopt the area as its own. The unspoiled northern sections of the Catskill Mountains have a mystery about them conducive to the creation of the awesome compositions of the Northwest Indian. Their untamed beauty—mountains, skies, storms and creatures—are a

persistent and inspiring presence. Allowing oneself to be overwhelmed by the powers of nature is the necessary first step to understanding the Indian and his ways.

As a child, I was initially troubled that I could not reconcile the Indian art I saw with the myths I heard. I learned later that this was because the art memorialized too many things to tell a coherent story simply: totems recorded family histories and rights at the same time that they told portions of the old myths. And all these things were so intermingled that only those who were present when totem poles were erected were privy to all their secret meanings.

It is not that the myths and the graphic forms did not mean much to me as separate entities, I was just disappointed that the one did not more directly illustrate the other. I felt that a new richness and meaning would be given to both the myths and the art if they could be perceived together. I decided, therefore, to devote myself to reconciling myth and image. I set about carving totem poles and making masks that just illustrated the legends: leaving out the family chronologies that made the old art difficult to understand. I incorporated tribal histories in my designs only if they were essential to the story.

In undertaking this task, I also wanted my art to be in the visual tradition of the early Northwest Indian, leaving out Western symbols or ways of representing reality. So I spent much time on the

Northwest coast examining the decaying remnants of ancient totems and murals until I felt I had sufficiently expunged the Western Art tradition from my intuitive ways of making form. As an indication of how I worked, I include four photographs (Figs. 1a, b, c and d): two of old totems that were my inspiration; and two of small sections of my Frog Mother totem (which I present in full later).

The myths and legends of the Northwest Indian speak to many things: they record the history of a tribe and its various clans; they tell how these tribes established themselves in certain areas and came into conflict with other tribes; they explain the origins of the earth, man and other creatures, and they tell how the sun, moon and the stars came into being. They provide important lessons about life and death; they explain how men and women should behave towards each other, and how mankind must learn to respect the creatures it depends on and with whom it shares the earth.

In the days before the Indians were assimilated into Western culture, these myths and legends were used to educate children. When the myths were carved into totem poles, they became the equivalent of illustrated story books that intrigued the children, helped them to remember the legends and led them to read the stories for themselves.

All the art in this book, except for the black-and-white reproductions of old photographs, is my own. Although my versions of

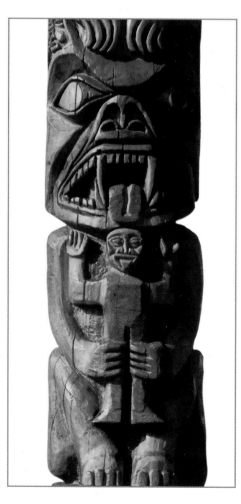

Fig. 1d

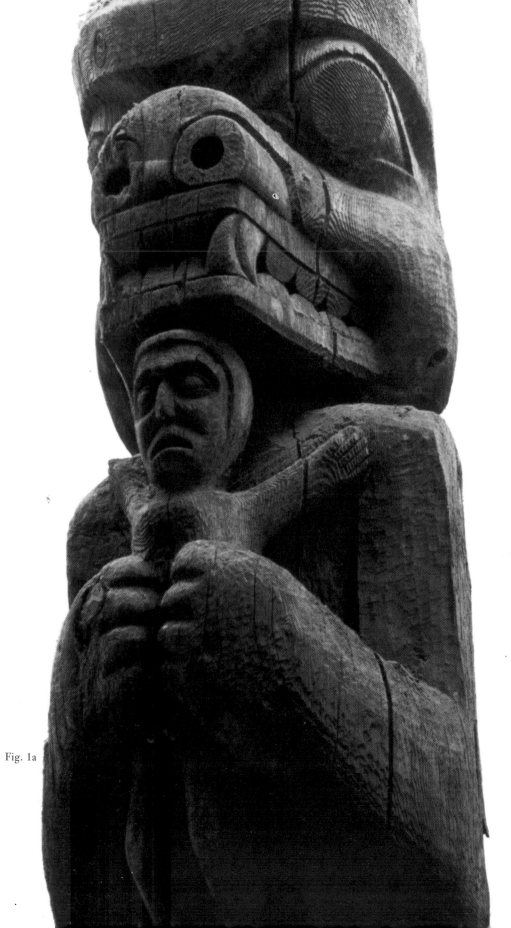

Fig. 1a

Secret Stories in the Art of the Northwest Indian

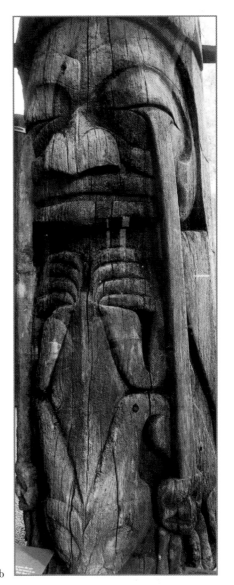

Fig. 1b

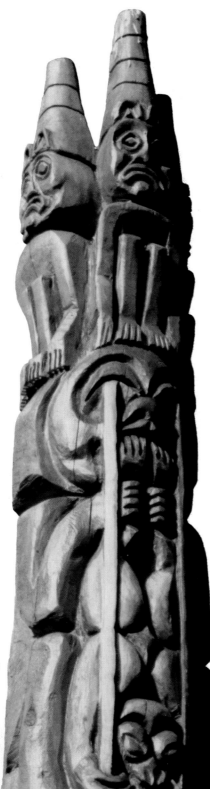

Fig. 1c

Figs. 1a, b, c, d: Old Totems Are My Inspiration

All my Northwest sculpture and paintings are based on the traditional Indian forms. I do not mimic them exactly, nor compose them in the same way, but I do strive to capture their likeness and be true to the way the Northwest Indian perceived objects and assembled them to tell stories.

Figures 1a and 1b are remnants of old Northwest Indian totem poles that now reside in museums. Figures 1c and 1d are portions of my Frog Mother totem that were inspired by these old totems (see Frog Mother Totem on page 83.)

the myths and the visual imagery are carefully based on the stories and art of the Northwest Indian, I have allowed myself some liberties. I have reworked the way these stories are told to make them more accessible to contemporaries and have used them to tell about day-to-day Indian life as well. There will be some who will take exception to the liberties I have allowed myself. I apologize to them beforehand, but I feel it is the only way to reveal the visual art and the myths of the Northwest Indian simultaneously.

To the Northwest Indian raised in the old ways, myth and visual imagery were one. But for those outside these traditions, the two remained separated. It is true that, as Westerners, we have learned to distinguish individual creatures in the art of the Northwest Indian (thunderbird, bear, killer whale, raven, etc.), but beyond that we have progressed little. This is akin to having learned the alphabet without going on to read—and there is a world out there to be read. I hope I have provided an initial guide for further reading.

Over the past few decades, there has been a major revival of Northwest Indian culture. Not only are more Indians now devoting themselves to their art, they are readopting the old beliefs and practices. But this is a recent phenomenon. Most Northwest Indians had been converted to Christianity, whether Catholic or Russian Orthodox. With the onslaught of the Europeans in the 19th century, the Northwest

Indian population declined rapidly. They died from smallpox and venereal disease. They were dispersed by government ordinance and missionary zeal. The white man also provided jobs to the commoners and slaves within a tribe that enticed them to abandon their villages. Children were forcibly taken away from their parents to be educated by whites in orphanages and rapidly assimilated into Western society—a well-intentioned but catastrophic policy of the Canadian government. Between 1850 and 1900, the Indian population declined by 80 percent. By the early 1900s, most of the once prosperous villages were abandoned. Only recently has the population of the Northwest Indian returned to the numbers of 1850.

In talking about the Northwest Indians, their life and art, I was not certain whether to use the present or past tense. Although some of the rituals are beginning to be practiced again today, they really are of the past—as are the myths and family histories. So I concluded that it would be more appropriate to talk about the Indian ways as if they were of a past time. Let us hope that the past will see a complete revival.

Oscar Newman (Bounding Warrior)
Windham, New York

Introduction

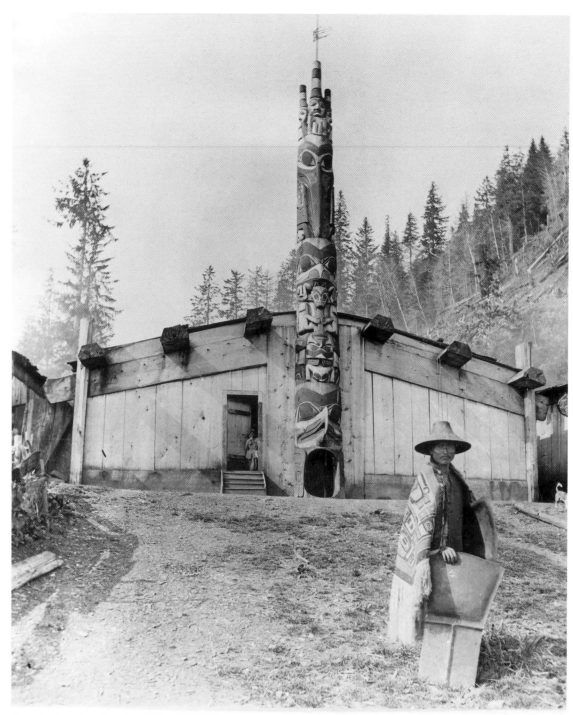

Fig. 2a: A Haida Chief standing in front of his own house. He is wearing a Chilkat Blanket and a woven hat made of tree roots, both of which show his importance. Two copper shields, which confer even greater status, are by his side. His house is constructed of heavy wood beams and split timbers that form planks. These planks make up both the roof and siding of his house. The old entry to the house was through the hole at the bottom of the totem pole.

Art in Northwest Indian Life

Although many Indian tribes in North America have a fine tradition in jewelry-making, pottery and weaving, the art of the Northwest Indian stands alone for the greater variety of its artifacts, the volume of output, its commanding size, and how fully it is integrated into all aspects of daily life and ritual.

The Northwest Indian lived in houses that were beautifully assembled from very large native, redwood timbers (Figs. 2a, b). This wood was often carved and painted to add texture, color, ornament and symbolism (Fig. 3). The interior of the houses of great chiefs contained stages on which elaborate rituals, dance ceremonies, storytelling, eulogies and negotiations took place (Fig. 4). Family crests, clan symbols and myths were incorporated into murals and carved into house posts. They served as constant reminders of the tribe's link to the past. These prevailing symbols were witnesses to the stability of the culture and confirmation of every tribe member's own worth and rightful place on earth.

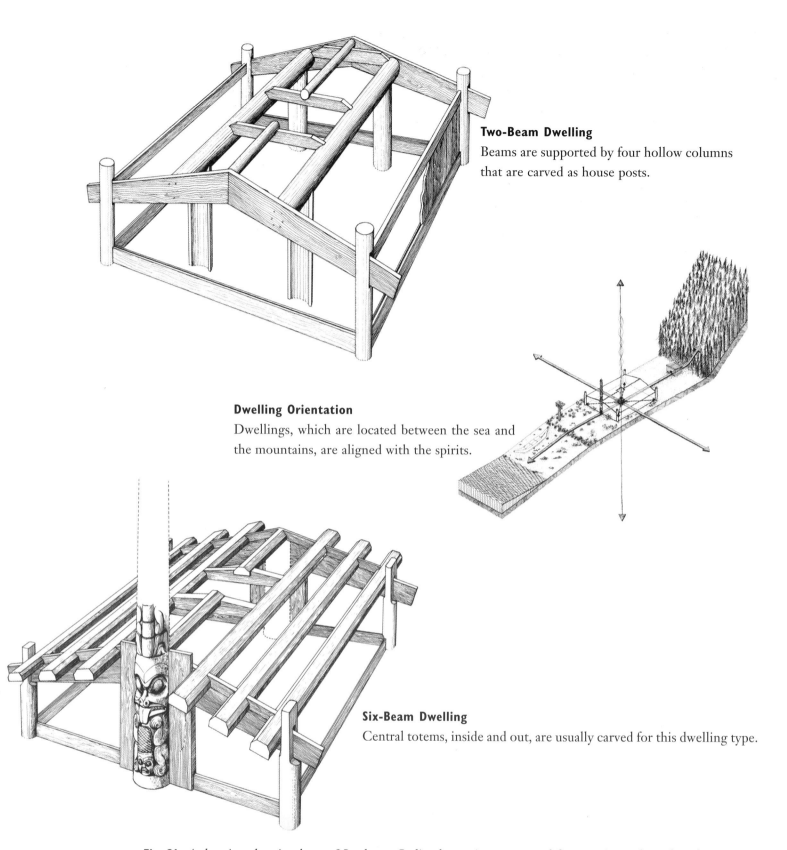

Two-Beam Dwelling
Beams are supported by four hollow columns that are carved as house posts.

Dwelling Orientation
Dwellings, which are located between the sea and the mountains, are aligned with the spirits.

Six-Beam Dwelling
Central totems, inside and out, are usually carved for this dwelling type.

Fig. 2b: A drawing showing how a Northwest Indian house is constructed from native redwood timbers.

Used with permission of the Publisher from *Haida Monumental Art: Villages of the Queen Charlotte Islands* by George F. MacDonald. © The University of British Columbia Press 1983. All rights reserved by the Publisher.

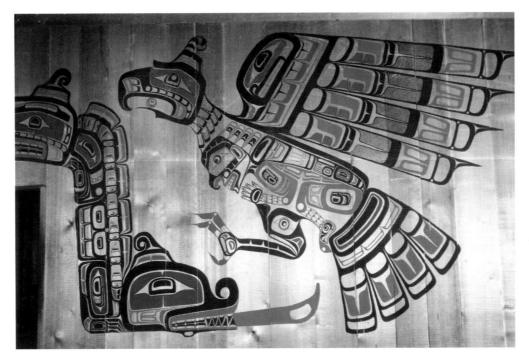

Fig. 3: Painting of an Eagle and a Sisiutl on the front of a Northwest Indian house.

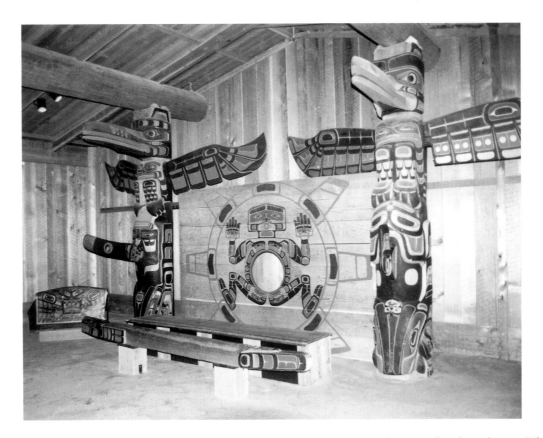

Fig. 4: The raised platform and rear wall of the interior of a Northwest Indian long house. This area is set aside to be used for ceremonies. Two carved house posts, each with wings, support the beams that run the full length of the house. A mural is painted on the rear wall.

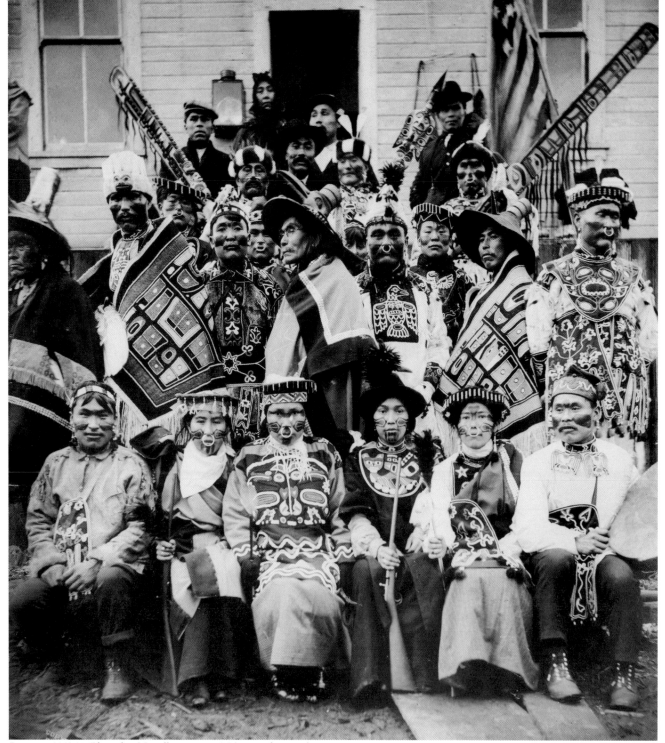

Image #: 328740. Photo by: Merrill, American Museum of Natural History

Fig. 5: Tlingit chiefs gathered at a potlatch held at Sitka in 1904. Virtually every article of clothing—shawls, vests, hats, canes, leggings, shoes—is decorated with the family crests claimed by the chiefs. Some chiefs also carry flat boards that serve as miniature totem poles reflecting their rights and privileges.

The Northwest Indians decorated every article they used in ceremony: masks, headdresses, shawls, rattles, aprons, copper shields and painted boards (Fig. 5). Each of these incorporated the crests of the owner and proclaimed his clan associations, family history, rights and privileges. Even utilitarian objects, such as storage boxes, were intricately carved and decorated.

It is difficult for Westerners to understand the true value of these objects to the Indian. Their beauty, the painstaking effort taken in their manufacture and the cost of the ingredients used only determined a small part of their value. Symbolically, ownership of the crests was equivalent to owning the firm behind a contemporary logo, such as NBC's peacock.

Totem Poles and Carvings

The Northwest Indian produced many different types of vertical carvings, from small staffs and replicas of human figures to sixty foot totem poles. Not all of these are called totem poles. Only those that embody religious as well as kinship significance can be called totems in the traditional sense of the word.

Frontal Poles

Most of the old totem poles we see in museums stood against the front of houses that were occupied by extended families or clans. These houses were built with huge timber beams and stood quite close to each other in long rows facing the sea (Fig. 6). The poles were usually placed where the roof peaked and were directed toward the sea. Frontal poles were twenty to thirty feet in height and served to identify the family. The poles were topped either with the family crest animal or with sculptures of human "guardians" who wore ringed hats.

Originally the frontal poles had large oval holes hollowed out of them at ground level (Fig. 7). One entered the dwelling through these portals. But as the Indians witnessed how the white man built his houses—with a raised floor to be above the cresting tides, a small set of stairs leading up to that level and a hinged door—they quickly adopted this system as their own. Subsequently, the frontal pole was located either centrally or to one side of the roof peak and served primarily for identification rather than for entry.

House Posts

Another carved pole that appears frequently in museums is the House Post. These stand eight to ten feet in height and were used in the interior of the dwelling as supporting columns for the heavy beams

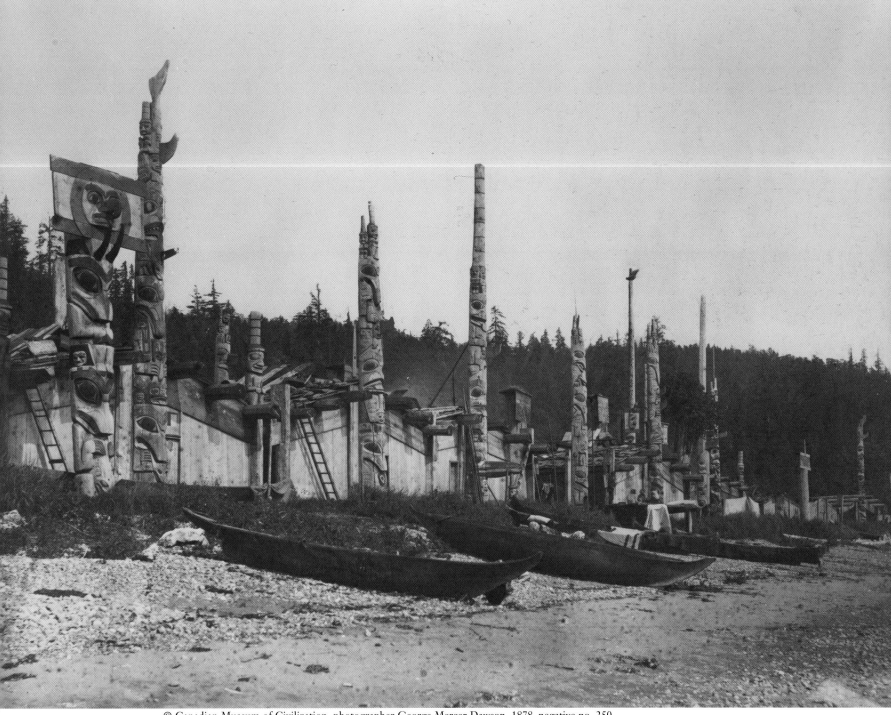

© Canadian Museum of Civilization, photographer George Mercer Dawson, 1878, negative no. 250

Fig. 6: A late 19th century photograph of the Northwest Indian village of Haina, located a few miles from Skidegate on Queen Charlotte Islands in British Columbia, Canada. The large wooden houses are set in a tight row facing the sea. Each house serves the extended family of a chief, consisting of as many as 50 people. A frontal pole is attached to the seaward face of each house. At the far left and far right, one can see a few mortuary poles, distinguished by the decorated boxes they support and by the head of a mountain goat that appears immediately below the box. The two very tall poles are memorial poles. The household canoe is pulled up on the beach in front of it.

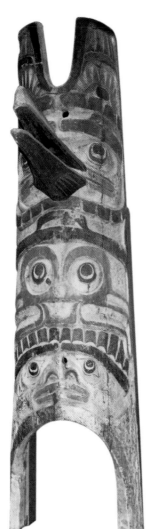

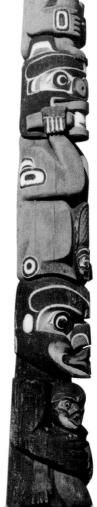

Fig. 7

Fig. 8

Fig. 9

Fig. 7: The opening at the bottom of this frontal pole was used as a ceremonial entry to a dwelling.

Fig. 8: House Posts, such as this, support the long interior beams of the house. They are usually carved to tell myths that are tightly interwoven with clan and family history. They serve as heraldry as well.

Fig. 9: A Memorial Pole records the clan histories and rights of an important chief still living in the house. Such poles are usually attached to the front of his dwellings. At the death of a very prominent chief—the one who gave the village its name, for instance—an even taller Memorial Pole may be erected in front of a group of houses at the main boat landing.

that spanned the length of the house (Fig. 8). These poles also portray family crests, but usually as part of a myth or legend. As indoor poles, they were tailored for the inhabitants of the house and were often used as a storytelling device for children.

Memorial or Heraldic Poles

The tallest and most prominent of poles, and the ones most often referred to as the true totem poles, were the memorial, or heraldic poles. These were commonly fifty to sixty feet in height and stood at the center of the village away from any buildings. They were erected following the death of a great chief who was the head of the entire village. Such a pole illustrated the entire lineage of the chief. Although they were usually erected at a potlatch ceremony a year after a chief's death, some chiefs began having them carved for themselves years before their deaths (Fig. 9). I will explain potlatches shortly.

To record a chief's lineage, a memorial pole would be adorned with the animal clans of his forefathers, beginning at the top with his most ancient or important ancestor and ending at the bottom with himself. The proverbial "low man on the totem pole" was hardly that in the chief's eyes, for he was positioned there to be seen at eye level and at a scale that dwarfed and overwhelmed the viewer. By definition, the taller the totem, the longer the known lineage and the more credible

the chief's claims to various rights and privileges. There is a tragic incident of two rival chiefs who competed to erect the tallest totem pole. When it became clear that one pole would be significantly taller than the other, the owner of the shorter pole shot the other chief dead—an extreme if effective way of cutting a competitor down to size.

Because marriage between important families and clans was often encouraged from generation to generation to retain certain rights, similar images occur within the same totem. Originally such poles, although very tall, were carved simply, consisting of a long shaft unadorned with anything but rings, and a carved creature set at the top and bottom.

Almost all totem poles, from the tallest memorial poles to the smaller house posts, are made from half a log. The full tree is split down its length and its core is hollowed out just after it has been cut down. This was done for three reasons: to make it easier to move the log; to keep the log from checking, and to make it easier to erect the carved pole. The core of the log contains the hardwood and the exterior the softer wood. As these two portions of the tree dry at different rates, the face of the log would split wide open if the log were kept fully intact. Removing the core for the full length of the log limits its splitting, or checking.

Mortuary Poles

Mortuary poles were used to support a wooden box that contained the bones of a dead chief. Ordinarily, one pole was used to support the box, but there are instances where two poles were used. Both the box and the pole supporting it were heavily carved. Two creatures appear repeatedly on mortuary poles (Fig. 10): a mountain goat (carved into the pole) and a hawk (carved into the face of the box). The hawk is usually portrayed with a human face and is shown swallowing its own nose. This figure represents death. The mountain goat represents the climb to the village of the dead that souls must make. The village of the dead is located where the mountains meet the sky.

The assemblage of planks that make up the wood front of the box is highly stylized: two horizontal planks with sharpened ends define the top and bottom of the box and two curved planks surround the head of the hawk. The hawk's head, with projecting beak, is carved from a single piece of wood. The flat front of the box was sometimes decorated with mythological or symbolic creatures.

Welcoming Poles and Carvings

Other types of poles and tall carvings of human figures served as welcoming or boundary defining symbols. Tall human figures, some as high as forty feet, stood with arms outstretched both to welcome and to

intimidate the visiting stranger (Fig. 11). On occasion, two carved columns supporting a long cross beam defined the entry to a village or to an important clan house.

Guardian Figures

Carved human figures were also used both to protect areas of sacred ground and to serve as effigies of the dead. At the burial ground for whalers, considered the bravest of hunters, human effigies stand clustered together among the skulls of the dead (Fig. 12).

I have carved many of these different types of totem poles and use them primarily to tell the myths and legends of the Northwest Indians and their way of life.

Fig. 10: A Mortuary Pole containing the skeletal remains of a chief. The folded over skeleton is placed in the box at the top of the pole. On the face of the box is the head of a hawk (in semi-human form) that is swallowing its own beak. This represents death.

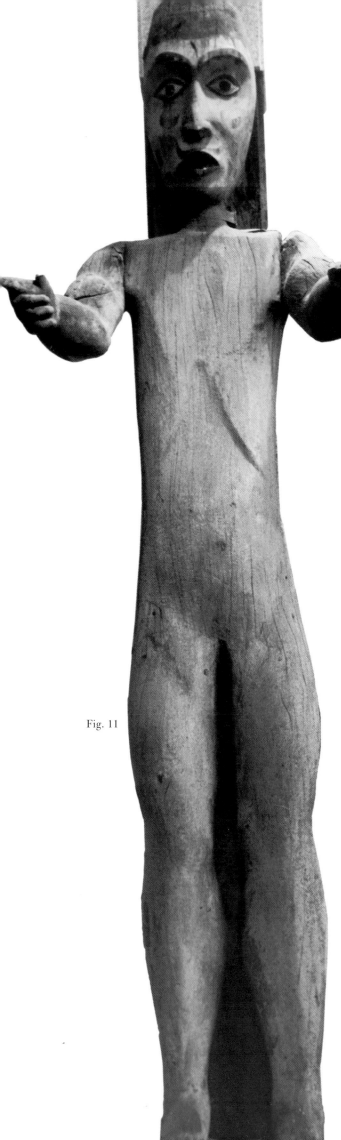

Fig. 11

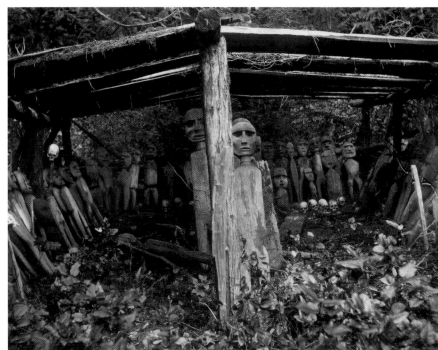

Fig. 12
Image #: 104478. Photo by: Hunt, American Museum of Natural History

Fig. 11: Village Welcoming Figure. These imposing figures, 20 to 40 feet in height, were placed at the entry to villages to both welcome and intimidate visitors.

Fig. 12: Guardian Figures at a Nootka shrine for whalers.

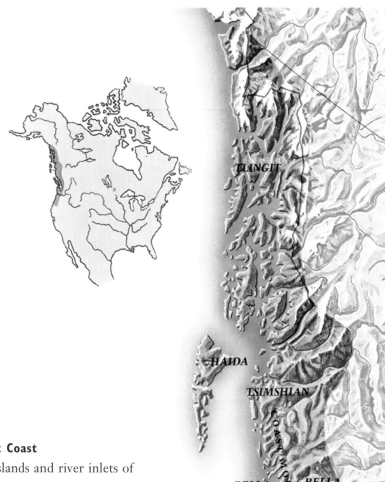

Fig. 13: Map of Indian Tribes of the Northwest Coast

Dozens of tribal groups crowded into the islands and river inlets of the Northwest Coast. Their terrain extended from just north of the Copper River in Alaska to the border of present-day California.

The powerful Tlingit dominated the northern stretches in Alaska. The Haida and Tsimshian, who were fierce rivals in battle and trade, controlled the central portion. Several groups to their south—the Kwakiutl, Heiltsuk (Bella Bella) and Makah—were related by common language and ancestry.

The Nuu-chal-nuth (formerly called Nootka) occupied most of Vancouver Island and traded with Europeans at Fort Victoria. This is where both sides of my family come from. The Coast Salish communities controlled the coast east and south of Vancouver Island.

The coastal areas still farther south, stretching from Seattle to Northern California, were occupied by the Chinook, Coos and others. Those tribes had ongoing cultural and trade contacts with Indian societies of the Plateau and Northern California.

Used with permission from *America's Fascinating Indian Heritage*, copyright © 1978 by The Reader's Digest Association, Inc., Pleasantville, New York, www.rd.com. Map by George Buctel.

Northwest Indian Culture

Uniqueness Through Isolation

The unique tradition of the Northwest Indian is explained in many ways. The geography of the Northwest Coast made contact with the inland Indians difficult, leading to the development of a more distinctive culture. The Northwest Indian lived along a narrow strip of land hemmed in by the Pacific Ocean on the west and coastal mountain ranges to the east. While this isolation allowed them to develop differently, it does not explain why their culture devoted so much energy to the pursuit of the visual arts (Fig. 13).

It is possible that the comparative ease of traveling south down the coast, rather than west across the mountains, provided more contact with Southwest and Mexican Indians. The visual arts play an important role in both of these cultures. On the other hand, the Northwest Indian's affinity for the arts may have come from a shared heritage with the Southwest and Mexican Indians, or it may be the

consequence of their shared sedentary way of life, in comparison with the more nomadic ways of the inland Indians.

Some anthropologists suggest a more fanciful history for the origin of the artistic tradition in the Northwest Indian. They say that centuries ago the Chinese moved across the north Pacific, either by land or sea, to settle the Northwest coast bringing with them their rich history in the visual arts. Others suggest that the Northwest shore was visited by natives of the South Pacific, who also have a tradition for carving.

Various economic factors were critical in freeing up the manpower and resources needed to devote to the arts: the abundance of food available in the seas and rivers of the Pacific Northwest; the ability to preserve this food over the winter months; the wealth accumulated through trade with other tribes and foreigners for goods that were readily available in the Northwest (furs, fish, oil, timber), and the abundance of natural carving and construction materials, in particular the giant redwoods and cedars exclusive to the area.

This wealth of resources led the Northwest Indians to settle into and remain in certain areas, just as Indians of the Southwest and Mexico lived off agriculture. In contrast to the migratory inland Indian tribes who followed animal herds, the Northwest Indians developed a culture that required the protection of settlement rights and of hunting and trading privileges. With the accumulation of significant wealth, a

detailed social hierarchy developed to define how it would be handed down to subsequent generations. The construction of large villages and permanent dwellings was the direct consequence of this wealth, and the totemic monuments served to enshrine it. That is to say, the totems became monuments to the ancestors who had first acquired the wealth and privileges and whose memories had to be maintained in order to preserve these settlement rights.

Religious Beliefs

The Indians of the Northwest believed that they shared a common ancestry with the animals they lived among, and that the untamed spirits of these animals endowed them with certain powers: to be fierce in battle; to be keen and successful hunters, and, on occasion, to change the course of nature. This form of religion is called Animism. It is the belief that the powers inherent in the natural environment—in animals, mountains, rivers, storm clouds, the sun—affect the outcome of daily events.

Clan names (as different from tribal names) were selected from animals. The animals' images were used as identifying crests in dress, in murals, in masks and in totems. The animals the Indians selected were those they depended on for food, those they admired for their hunting skills, or those with whom they had a memorable encounter (although not

always a pleasant one). The Indians saw their own spirit as wedded with the spirit of the animal they identified with. Most families or clans chose a majestic hunting animal—usually a carnivore—for their family forbear: eagle, bear, killer whale. It was even said that the shaman of a tribe could turn himself into an animal at will. A shaman is a medicine man and magician, and occasionally a spiritual leader. He cured sick people, brought rain and prepared a tribe for battle by bringing good omens. In the old days, the ability to turn oneself into an animal was a skill that chiefs had as well.

Movement of Tribes

Thousands of years ago, when the Indian tribes first began settling the Northwest, few territorial rights existed and there was much movement up and down the coast. The temperate sea provided a year-round artery for travel. There is evidence that Asiatic people crossed the northern Pacific on ice in the winter and made their way down the coast to compete with and find a place among the already established native populations.

The myths indicate that in the early history of the Northwest Indian, it was not uncommon for an aggressive new tribe to appear from the ocean and attempt to set up camp near an existing village. This is said to have occurred a few times during the lifetime of a single person.

Intermarriage among the newcomers and an established tribe was a common way to reduce conflict between them. Because clans bore the names of animals, this competition between clans is often recounted in stories involving bears, eagles and killer whales. These legends are nevertheless understood as being clan histories, or pre-histories—much as the great myths of peoples from around the world recall a time when the earth was occupied by gods and superhumans—before the emergence of man as the dominant creature.

Legends and Myths

Legends tell of the ancestral histories of Northwest tribes and clans. They explain how the Indians emerged in the Northwest and how various tribes settled in particular areas. They talk about the obstacles they had to overcome and of the encounters they had with other tribes (sometimes in the form of animals) or physical phenomena (floods, supernatural animals, monsters).

These legends were of critical importance to the continuity of these tribes because they gave legitimacy to their presence in certain areas and to their hunting, fishing and trading rights. The truth of such legends was undisputed. To question them was to issue a declaration of war, for all social constructs and possessions were based on them.

When legends are told through an interweaving of visual crests, these crests become icons or totems which take on a magical power of their own—they not only embody the legend, they are the legal documentation of it. That is why the crests are incorporated into totem poles and murals, masks and garments, rattles and sticks. They are brought out on important occasions: the death of a chief, the marriage of a daughter, the birth of an important heir.

Myths, by contrast, are tales of cosmology: how the earth and man came into being; how supernatural creatures interacted with man, and how superstitions were born. Generally speaking, myths are not taken too seriously by Northwest Indians because little of consequence hangs on them. Whereas a tribe's livelihood depends on the veracity of its legends, myths are not worth fighting over. Myths serve to fill in the unknown voids about creation, explain peculiar sightings and reveal the meaning behind terrifying dreams. The rendering of these myths in visual forms (poles and murals) results in a product that is without totemic significance.

Social Organization

Northwest Indian society was hierarchical rather than democratic. Dominant males ruled their tribes as chiefs. Their immediate relatives were the lesser chiefs, or what we might call nobility.

The rest of the tribe, all of whom were carefully graded as to rank and status, consisted of more distant family with less skills or accumulated wealth. There was also a slave population living among each tribe. These were either people taken captive in battles with other tribes or destitute tribal members who gave themselves up as slaves to noble families in order to survive. Evidence suggests that these slaves lived quite normally with their masters and other tribe members, but their lives were considered worthless because they could be taken at will by their owners. Slaves were occasionally given to other chiefs at potlatch ceremonies or sacrificed to lead the way to the spirit world for a dying chief.

All wealth and power rested in the tribal chief. He rarely handed down his wealth to his own children—instead he gave it to the children of his older sister. This was thought to be a better way of keeping wealth within the same genetic pool. This form of social organization and succession is called matrilineal.

The tribal names of the Northwest Indian (Haida, Tlingit, Kwakiutl, etc.) reflect the territory historically occupied by a group of settlements that were family-related. (Some anthropologists claim that these are not true tribes but extended families.) Clan names such as Bear, Raven, Wolf and Eagle reflect associations within the family, power groups within the tribe and social groups that have certain rights and obligations. A single person could belong to many different clans,

depending on the associations involved. Generally speaking, the more prominent the person, the more clans and secret orders he or she belonged to.

For a start, every tribe was divided equally into two opposite clans that were not always related by birth. One of these clan-opposites was called Raven and the other Eagle (or in some tribes, Wolf). Although these clan-opposites, as entities, owned no property, they played an important role in social life. They regulated marriages and the organization of ritual services. In fact, the more critical rituals and ceremonies, such as burial and succession, involved a complicated interaction of the two clan-opposites, each performing important obligations for the other that they were not allowed to perform for themselves.

Each clan owned symbolic property, including crests, ancestral myths, songs, dances, masks, cloaks, hereditary names, titles and other prerogatives.

The Potlatch

Potlatching is a ceremony unique to the Northwest Indian. Important chiefs hosted large, sumptuous parties for many other chiefs and important people and distributed great quantities of goods among them. Dining and gift-giving were accompanied by singing, dancing and speechmaking. Each chief strove to outdo the other based on the size of

the potlatch and the number of gifts distributed. Gifts were carefully apportioned according to the relative importance of the recipient. One of the purposes of the potlatch was to confirm the carefully structured hierarchy among chiefs and nobility and peacefully accommodate marginal changes to it.

A potlatch was an acceptable way for a chief to affirm and enhance his stature. However, a chief's generosity did not always endear him to rival chiefs or reduce hostilities among them. Potlatching involved not only the distribution of commodities such as flour, gunpowder, blankets and guns, but the destruction of important symbols of wealth such as one-of-a-kind copper shields and even slaves. Shields and slaves were also given to other chiefs.

Goods were given away for two reasons: first, to show that the chief and his tribe were so wealthy they could afford to give away fortunes and second, to mollify any envious chiefs or family members who might not have had the chief's good fortune in trading, hunting or war. Upon the death of an important chief, a potlatch served as the reading of the will and the distribution of the chief's legacy. It also established a new hierarchy.

The word potlatch is derived from the Nootka word patshatt, which means giving. It became potlatch in Chinook jargon, the language spoken by fur traders in dealing with the Northwest Indians up and down

the Pacific coast. It was rare for a white man, other than an anthropologist, to attempt to learn one or more of the languages of the Northwest Indian. There were many different occasions for potlatching, some major and some minor, and the potlatches varied in size accordingly. The most elaborate potlatches were staged to confer a chief's rights and privileges to his heirs, or to bless the marriage of the children of important chiefs. Such occasions brought together all clans and family members as well as important neighboring chiefs.

Initially, Europeans thought that potlatching was invented by the Northwest Indians to settle disputes. Then it was seen as a way of distributing newly acquired wealth. Finally, it was understood as a way to invest one's wealth, because it was thought that the goods distributed had to be returned twofold by the recipients. In truth, chiefs gave more than they received to humble other chiefs, not because they felt obliged to do so. For them to give away goods with the implicit understanding that it would be returned twofold would nullify that gesture.

Only those chiefs who felt challenged or threatened by a generous potlatch gift felt obliged to outdo the giver. Short of war, this was the only way for a chief to assert his greater wealth and power and command respect for his rights and status. To this end, some chiefs borrowed large amounts of goods from other friendly chiefs to give to their adversaries. These borrowed items had to be returned in a year's

time with 100 percent interest (hence the misconception that the goods distributed in a potlatch had to be returned twofold). Such an arrangement could and did bankrupt entire tribes. As a result, for a while, potlatching was outlawed by the Canadian government.

It should not be supposed from the existence of the potlatch that the Northwest Indians were nonviolent. Coastal wars could be bitter. Once launched, they became expeditions to exterminate and capture enemies and to win over all their lands and wealth. For instance, in the mid 19th century, the Haida forced the Tlingit off Prince of Wales Island at great expense and loss of life to both sides.

Crests

The most important symbol of the clan and the matrilineal group were their crests. They were the Northwest Indians' most jealously guarded possessions. The totem crest of each clan-opposite and matrilineal group was a birthright, as tangible as any treasure and as real as life itself. Personal guardian spirits could, in extreme cases, be destroyed or driven away, but no act could ever change the relationship of an Indian to his clan-opposite or to his matrilineal group. Crests were acquired by one's ancestors under trying circumstances and were held in perpetuity by their matrilineal and clan descendants.

Most clans owned one or more major crests, and a number of secondary ones. Clan crests were also depicted in myths, songs and dances. As a rule, a mythical encounter between a clan's ancestor and an animal or creature resulted in that creature being depicted on a clan crest.

Myth Time

The Indians believed that they occupied two time frames simultaneously: myth time and real time. Myth time was a continuum that stretched back to primordial history. It was the ever-present record of one's origins, identities, loyalties and privileges. It codified the ways of the world and one's continuing obligations while functioning within it. Real time, by comparison, dealt with the mundane matters of day-to-day survival. In moments of crisis, the Indian would appeal to the spirits of the myth time to intervene in the events of the real time.

Distribution of Tribes Along the Coast

Figure 13, a map of the northwest coast of the United States and Canada, shows how the more important tribes of the Northwest Indian were distributed from southern Alaska to the State of Washington. The northern portion of the Northwest was dominated by the Tlingit, who specialized in masks, religious artifacts and wall paintings. The central portion was dominated by the powerful Haida and

Tsimshian tribes, who were the first and finest totem pole carvers. The southern portion was dominated by the Kwakiutl, the Nootka (Nuu-Chal-Nuth) and Makah, whose masks, figures and artifacts are highly spirited and often awe-inspiring.

The Tsimshians are recognized as being the very first carvers among the Northwest Indians. Even the Haida, who were more skilled, are said to have learned from them. Both Tsimshian and Haida carving is not very deeply incised but highly interwoven. Both tribes are very detailed and realistic carvers. On occasion, Haida carving is almost surface incised, as if just scratched into the surface.

By contrast, Kwakiutl carving is very deep. Their figures are more spirited and disjointed and do not interweave very much. They are distorted and almost caricature-like. The art of the Kwakiutl may capture the imagination of Westerners because it is, conceptually, so expressionistic. Kwakiutl poles are almost three-dimensional in their design rather than being flatly carved on a round surface.

The Bella-Coola, who are located between the Kwakiutl and the Tsimshian, are also excellent expressionistic designers. They do not seem to devote as much attention to detail as to expression, although some of their masks do show incredible detail.

Secrets Revealed

TOTEM POLES

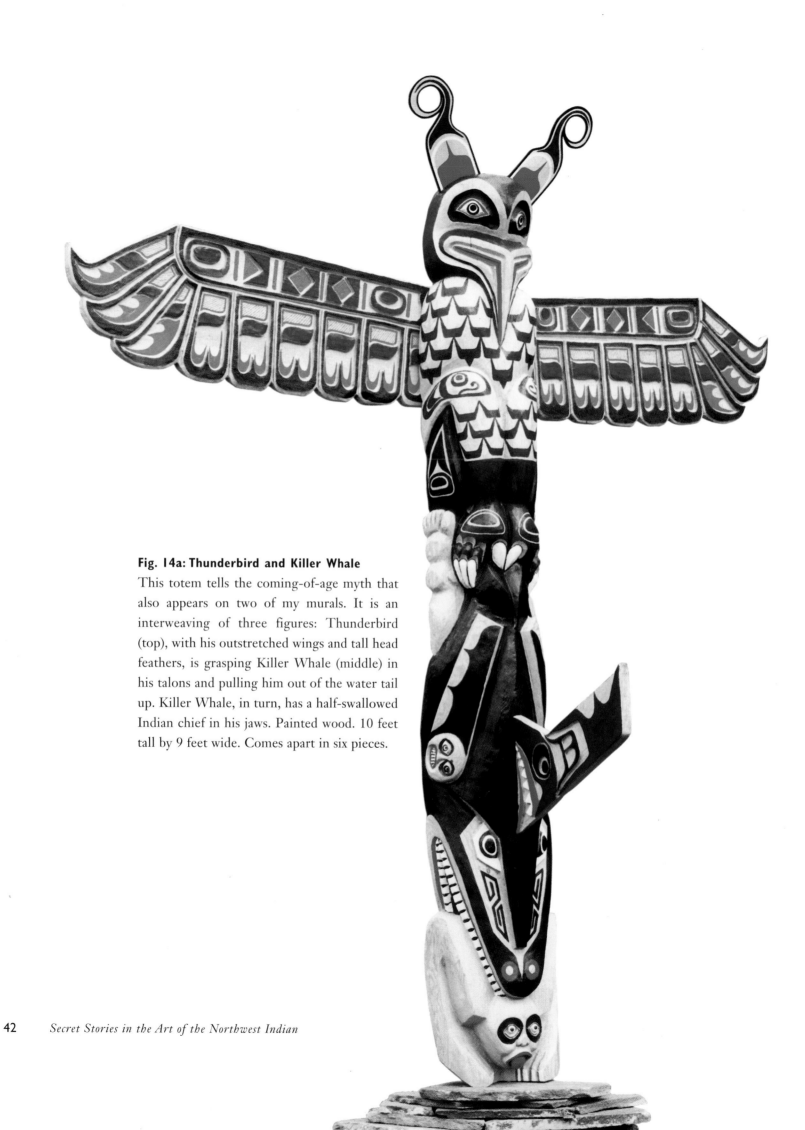

Fig. 14a: Thunderbird and Killer Whale

This totem tells the coming-of-age myth that also appears on two of my murals. It is an interweaving of three figures: Thunderbird (top), with his outstretched wings and tall head feathers, is grasping Killer Whale (middle) in his talons and pulling him out of the water tail up. Killer Whale, in turn, has a half-swallowed Indian chief in his jaws. Painted wood. 10 feet tall by 9 feet wide. Comes apart in six pieces.

Thunderbird and Killer Whale
(A Coming-of-Age Story)

A young Indian prince wished to marry a princess from the Salmon-Eater clan but was unable to win the approval of her father, a brave and wealthy chief who led the annual whale hunt. The men who hunted whale were considered the most daring of all hunters because whaling, although highly rewarding, took a costly toll on human life. It was not enough that the princess's young suitor was the son of a great chief, her father wanted him to prove that he was, himself, a brave and skilled hunter.

On his mother's side, the prince had an uncle who was a shaman—a magician and healer. Although still young, the prince had already begun to learn his uncle's magic ways. Wrapped around his arm was an angular snake, and by his side was a dog that looked and acted more like a wolf. The dog's bark was low in pitch, menacing and deafeningly loud. In fact, the angular snake and wolf-like dog were the lightning and thunder of Thunderbird. (Thunderbird is the spiritual embodiment of a huge thundercloud that passes overhead and brings the storm.)

The prince had also learned patience from his mother. Now, he waited for the right moment to show his skill and bravery in a way his future father-in-law would not soon forget. There was a reason the prince could afford to be patient: his future bride had confessed her love for him and was providing him with inside information about her father's weaknesses. She told him that her father was very arrogant and full of himself. The prince already knew that, for another man might have noticed the angular snake and wolf-like dog and asked himself if they had further meaning. The other thing the chief's daughter told him was that her father, the bravest whale hunter of them all, could not swim. The young man had known that he would have to use subterfuge to get the better of the girl's father, and this information gave him his chance.

When the chief asked the prince to join the whale hunt in the chief's own canoe, the young man insisted on bringing along his dog and snake. The chief gave him a spear, looked at his mangy dog and snake, shook his head and said: "I hope they don't get in the way of your spear."

That spring, the annual whale hunt was proving a disaster. A killer whale followed the school of whales on their migration north and was attacking the newborn calves. As a result, the mother whales were skittish and hard to approach. When the hunters were finally able to get close, Killer Whale turned over their long boats and attacked them. It became clear that if the whale hunt were to continue, Killer Whale would have to be dispatched.

The chief motioned the men in his boat to paddle toward Killer Whale. Tradition dictates that the right of the first kill belongs to the chief. When the chief leaned over the side of the long boat to locate Killer Whale, the prince tripped him up with his spear, and the chief went flying overboard. It happened so fast, no one noticed what the prince had done. Everyone's attention was concentrated on the chief who, unable to

swim, was thrashing about wildly in the water. This brought the chief to the attention of Killer Whale, who came rushing up to the surface. He grabbed hold of the chief and began to swallow him alive.

The other men were too terrified to do anything. Killer Whale was too large and menacing to approach. The prince quickly transformed himself into Thunderbird and sent his snake and wolf into the water to attack Killer Whale. His wolf turned into a shark and his snake into an electric eel. While Killer Whale was preoccupied with fighting off the shark and eel, the prince sunk his claws into him, lifted him and the chief out of the water and flew them back to camp. Before he landed, the prince shook Killer Whale so severely, he let go of the chief. The tribe rushed to the chief and rejoiced that he was still alive, if somewhat chewed up.

The young prince was received with great thanks and honor. Of course, the chief had no choice but to accept the prince as his new son-in-law.

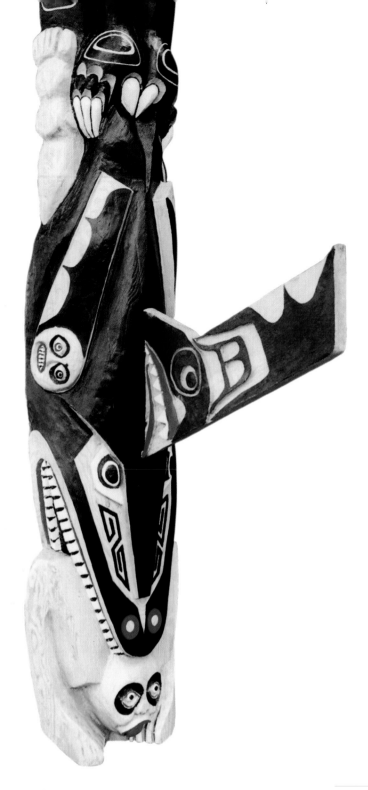

Fig. 14b: Killer Whale's two tail fins can be seen alongside the legs of Thunderbird. Within Killer Whale's mouth is the Salmon-Eater Chief (bottom). The dorsal fin on the upper back of Killer Whale shows his frightening face in human form. The joints of Killer Whale's side fins are also rendered as human faces.

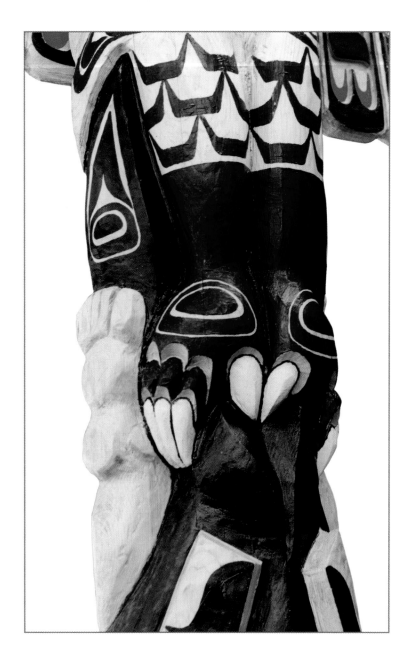

Fig. 14c: Traditional Northwest Indian carvers enjoyed playing tricks as well as telling stories with their carvings. Thus the feet of these three adversaries—man, sea mammal and bird—are shown in counterpoint with one another by being grouped tightly together.

The Raven Myth Cycles

The tales of Raven belong to the cycle of raven myths that are popular on the American as well as Asiatic shores of the North Pacific. They play an important part in American Indian cosmology, describing how the world was first created. But they have no role in religious observances. Raven is seen more as a transformer who betters the world, rather than as a creator who brings order out of chaos.

Raven appears prominently in the mythology and legends of the Northwestern Indian and was recognized as chief among their gods. Raven's scheming, unheroic, but effective ways of getting things done were revered by Indians as a model of pragmatism. Children, in particular, enjoyed his shenanigans and practical jokes, so stories about him proved a good way to entertain and educate children. Almost every Northwest tribe shares the legend of Raven and his friend Frog, freeing the sun, the stars and the moon to bring light to the earth.

How Sun-Raven Saved Mankind
from the Flood

When the earth began to warm up after the last ice age, the waters covered Alaska and inundated its villages. Raven quickly pulled the children of mankind from the flood waters and flew them up to the sky. In Figure 15a, the upper portion of the pole shows a frontal view of Raven with his wings spread apart. A skull on each wing symbolizes the dead in the waters below. Raven carries three children, symbolizing the children of mankind. The children have their arms interlocked to help balance themselves in flight.

The circle around Raven's head is the Sun. Beneath his feet is the Moon. The Sun and Moon are old friends of Raven, since it was Raven who first released them into the sky (See Raven and the Sun King).

On the lower half of the pole Raven is shown from above, rather than from the front. When the flood subsided, Raven descended from the sky. But the water still covered the earth and there was no place to land. Raven was too tired to fly back up into the sky with his cargo, so he called upon his friend, Frog, to help. Raven and Frog were old friends and enjoyed many adventures together. Frog rose to the surface of the

water and let Raven and the three children rest on his back. The two bottom figures on the totem depict Raven resting on the back of Frog. The children lie protected between them.

The upper portion of the pole shows the figures vertically, while the bottom shows them horizontally. Such shifts in time (before and after) and point-of-view were common in Northwest Indian design.

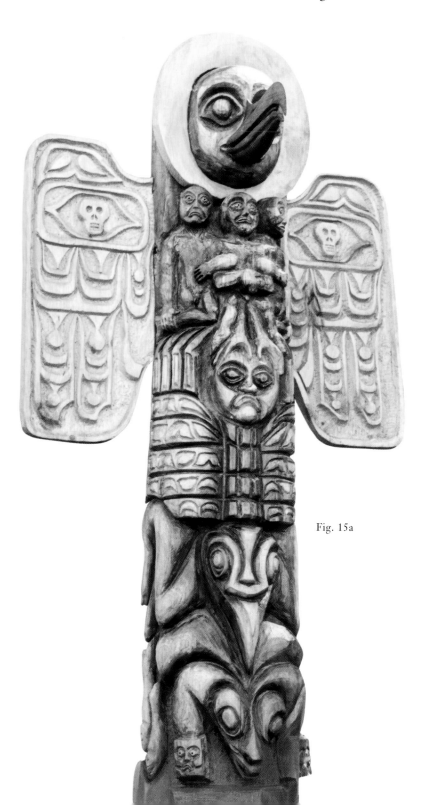

Fig. 15a

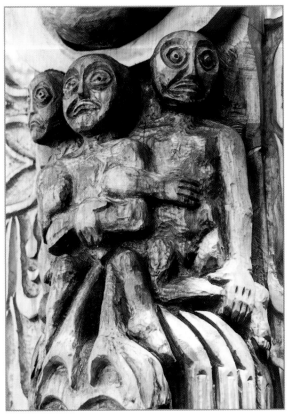

Fig. 15b

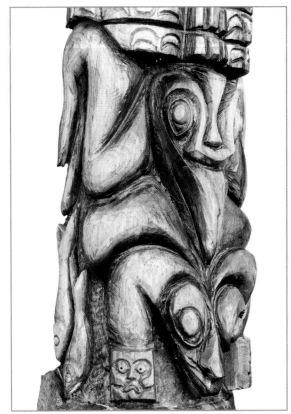

Fig. 15c

Fig. 15a: How Sun-Raven Saved Mankind from the Flood This is a totem of the Tlingit tribe. The original stood in front of Hall's Trading Post in Ketchikan, Alaska. One cannot look at the overall form of the Flood Totem without being reminded of Christian iconography: a winged saint with a halo. It is quite likely that the Northwest Indians, who were great borrowers of imagery, saw such an icon on either a Russian or Spanish trading ship and adopted it to tell one of their own myths. It is also possible that the idea of a universal flood was first acquired from a missionary.

Walnut and pine, 114 inches by 96 inches.

Fig. 15b: Detail of the children of mankind clinging together as Raven pulls them from the flood waters and flies them up to the sun.

Fig. 15c: Detail of Raven lying on the back of Frog with the fish of the sea swimming by.

Raven and the Sun King
(How Raven Freed the Sun, Moon and Stars)

When the earth was still young it was covered in darkness. Raven, being a friend of Man and all creatures, wanted to improve life for them by bringing light. But the Sun, Stars and Moon were owned by the King of Light, who kept them locked up in boxes in his home. Raven appealed to him to let them out so they could light up the earth, but the King of Light was a vain and power-hungry man and would hear nothing of it.

Now Raven was not a creature who was easily put off. He was always coming up with good ideas, and there was always some stubborn fool who stood in his way. Raven enjoyed a good challenge because it required cunning and deception, and he loved nothing better than outsmarting people—particularly vain and greedy people. Besides, Raven knew himself to be too cowardly to be much of a fighter—but bluffing his way around, now that was his style.

Raven had a friend in Frog, who was a lifelong enemy of the King of Light. Raven knew that Frog would never miss a chance to settle up old scores with the King of Light. When Frog and the King were still

friends, Frog visited the King often at his home. Raven thought he could use Frog's knowledge of the house to break into it and steal the Sun, Moon and Stars. But Frog soon put an end to this idea. "The King guards everything he owns very jealously," Frog said. Raven was not surprised: he knew that greedy people were very careful about their possessions, and he also knew that great deeds were not easily achieved.

Frog thought a bit more and told Raven that the King had a daughter he was very fond of. Like everything else he possessed, the King guarded his daughter very closely. She was a virgin and was always in the company of a chaperone. The King's daughter was allowed to drink from only one spring. So Frog, who had magical powers, suggested changing Raven into a pine needle, which Frog would then place into the spring. Since the King's daughter came to drink at the spring every day, Raven could swim toward her mouth and chances were that she would accidentally swallow him.

Raven agreed. No sooner was he turned into a pine needle and dropped into the waters of the spring, than the King's daughter came along and swallowed him up. The King's daughter became pregnant. The child was Raven. When Raven was born, he was welcomed into the home of the King of Light. In fact, the King, his grandfather, doted on him.

As Raven grew into a boy, he endeared himself more and more to the King. His grandfather loved him so much, he would give Raven anything he asked for. As good as life was for Raven, he never forgot his mission to improve the world by freeing the Sun, Stars and Moon. But the King of Light still kept them all hidden, locked away in boxes where Raven could not find them.

After a while Raven reasoned that only by making a disturbance could he learn where the boxes were. Pretending to be ill,

Raven cried for light and would not be pacified without it. His grandfather ordered one of his servants to open a large chest in his house and to take out the box containing Sun. He showed Raven how to open the lid and peek in to see the light without letting Sun escape. Raven stopped crying immediately, to the King's great relief. As Raven played with the box, he slowly moved it under the smoke hole of the house. Then he opened the box all the way and let the Sun escape through the hole. That is how Raven freed Sun and made daylight.

The King was horrified. He had kept Sun hidden and the world in darkness for so long, and now, in an instant, it was over. The King realized he had lost much of his hold over all the creatures of the world. But the King loved his grandchild too much to chastise him for his misdeed. Besides, the King still had Moon and Stars with which to deprive the world.

Initially, Raven was very pleased with his accomplishment. The earth was a different place now, with Sun to light it up all day. Creatures frolicked in it, plants grew, even the King of Light began to get out of the house a bit and could actually be seen enjoying himself. But Raven became dissatisfied. Sun shone only during the day: the night still remained dark.

So Raven again began to cry bitterly to his grandfather, complaining that the light from the box had disappeared into the sky. The King did not want to see his grandson cry himself sick, so he told his servant to bring out the box containing Stars. He gave the box to Raven, warning him not to throw the stars into the air or they would escape through the smoke hole. Instead, Raven rolled Stars around the floor until they escaped through the cracks. Frog, who was watching all this, directed Stars to float up to the sky.

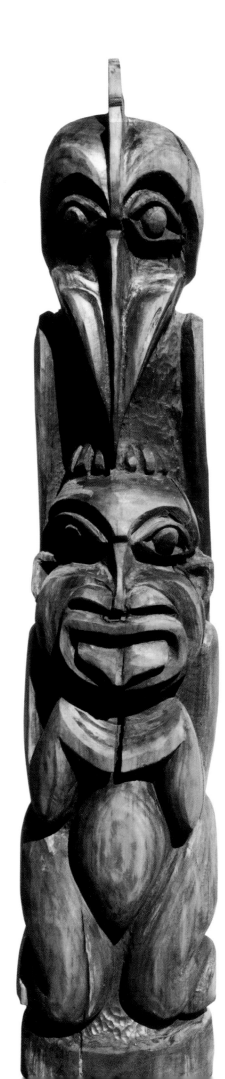

Fig. 16: How Raven Freed the Sun, Moon, and Stars

Victorious Raven is shown perched on the head of Sun King, whom he has just outsmarted. Sun King is on his knees, humbled. His tongue hangs out and his hands are palms down, further adding to this portrayal of him as an ineffectual fool.

The original of this totem was a House Post of the Bella Coola tribe. Part of it now resides at the American Museum of Natural History in New York City.

Walnut, 53 inches tall, free standing.

During the next few nights, Raven saw that Stars did not shed that much light. He had been hoping for a bigger change—the same effect produced when Sun it rose up into the sky to light up the day. So Raven began to cry again, hoping to be given Moon—the last box in the chest. But the King would not give up the last box and the power it held for him. No matter how much Raven cried, the King would not relent. The child obviously didn't know how to hold onto his toys. Raven cried every night and shed many tears, but the King held his ground. Raven refused to take any food and he began to get weak. The King's daughter pleaded with him. Finally, the King could do nothing but give in to her wishes. He gave Raven Moon to play with, but stationed a servant to sit under the smoke hole to make sure the child would not let Moon get away. The King knew that Moon was too large to fall through the cracks in the floor.

Raven rolled Moon around the room for some time, looking for an opening. Moon was too large to fall through the cracks in the floor, and the King's servant was guarding the smoke hole. Raven began playing near the door. He told the servant that there was someone outside trying to get in. The servant told Raven to hold onto Moon tightly while he opened the door. Raven agreed, but when the servant opened the door, Raven pushed Moon through it. The King looked at his grandson angrily and saw for the first time that he resembled Raven. He understood at last that he had been tricked. Charging at Raven, the King tried to strangle him, but Frog quickly changed Raven back into his original state. Raven grabbed Moon in his beak and flew up to the heavens. There Raven installed Moon as Chief of the Night. He instructed Stars to act as Moon's servants, and he made Sun Chief of the Day.

Reflection on Generations
(Deceit Can Take You a Long Way)

Orong, a proud and able Eagle chief of the Bat clan, aspired to become the head of all the chiefs in his tribe. He knew that he was both braver and richer than the other chiefs, but that was not enough for him. He wanted to be recognized for this and to be made king of his entire tribe. The other chiefs resisted. Although many tribes in the Northwest did have kings—or a single chief who was superior to all the other chiefs—this tribe did not, and they were reluctant to change their traditional ways.

It was not that the other chiefs did not know that Orong was the bravest among them; his skill as a warrior and hunter was renowned and undisputed. Every battle he led proved victorious and netted the tribe much booty and slaves. Orong was also a well organized and skillful hunter which, together with his warrior skills, made him the wealthiest among the chiefs. Finally, he had a very chief-like demeanor. He carried himself well, spoke elegantly at potlatches, wore beautiful masks and cloaks and sang the dirges mournfully. He never shouted or threatened anyone. His word carried great weight, because he always true to it, and furthermore, he saw to it that others were truthful as well. Orong was

also very generous. After battles and successful hunts, he distributed the newly acquired wealth fairly among his fellow fighters and hunters.

In other tribes, such attributes would have made a man like Orong king—the chief of chiefs—by consent and without argument. But the tradition in this tribe was for all chiefs to be equals, regardless of their individual skills, wealth and the relative size and importance of the clans they belonged to.

Try as he might, with argument and with generous gifts, Orong could make no headway in convincing the other chiefs that he should become their king. Finally, he gave them all an ultimatum: either they made him king or he would pull his clan out of the tribe and move up the coast to create his own new tribal village. He also explained that those who remained would no longer be under his protection, for it was common in this area for tribes to raid each other as a means of settling scores and acquiring new wealth and slaves. Because of Orong's reputation as a warrior, no tribes had ever dared to attack his village.

The other chiefs met and discussed Orong's ultimatum. They were not fools. They understood the hidden meaning in his message. When Orong said that he would no longer protect those who remained, he meant that they would be open to his attack. Moving away was one thing—the rest of the tribe would find a way to make do without the mighty Orong—but having him as a potential enemy, that was serious. They knew what he had done to other villages. They could all end up dead, their possessions taken away, their old folks killed and their wives and children made slaves. They said to each other: "We must be clever. If we refuse him outright, he will move away and we will have earned his wrath, and then what? Better to deceive him. Tell him that we want him as our king, but that our reluctance stems from one uncertainty: we are concerned that he has produced so few children. Kings must be brave

and wealthy, but they must also be fertile and produce many offspring." It is true that Orong had many wives, but he had produced only two children, whereas most of the other chiefs had a dozen or more. A king had to to leave many heirs, because illness, injury and hunger took the lives of so many children among the Northwest Indians.

"What could Orong say to that?" the chiefs reasoned. Knowing Orong, they were sure that he would immediately want to demonstrate that he was fertile. But it takes a long time to produce offspring, particularly for Orong, who had been married to three wives for five years but still had produced only two children. By the time he demonstrated that he too could produce a dozen, he would be too old to be a threat to any of them. The other chiefs laughed and congratulated themselves on their cleverness.

So they met with Orong, and they praised his bravery, wealth and wisdom. They told him that they were prepared to give up the old tribal traditions and make him their king. Orong was very pleased. But there was one problem, the chiefs added quickly. Orong raised an eyebrow. What was that? he asked. Orong has so few children, they told him. The tribe wanted to be guaranteed a succession.

Orong went from glee to gloom in an instant. It is a wise man who knows his own limitations, and Orong knew that producing offspring was not one of his strengths. He nodded his head, accepted the reasoning of the other chiefs and agreed that their concerns were legitimate. He thanked them for offering him the crown.

Orong walked home silently and with much reserve. He knew he was being watched, and he wanted to preserve his regal demeanor. But in the privacy of his own home, and among his closest kin, he ranted and raged: How dare they offer me the crown while questioning my virility! His three wives rushed to shore up his deflated

ego. They knew there would be hell to pay if his self-pitying was allowed to continue.

The reason he had so few children, his wives explained, was that he spent so much time away from home hunting and waging war. He was never home long enough to produce offspring. Orong sent his wives away in disgust. Long enough, indeed, he fumed.

After he had calmed down, Orong went to see the aging and retired chief of his own clan. Orong did not have to tell the old chief what had happened, he already knew. How he could know without ever leaving his house or speaking to anyone was one of the great mysteries about the former chief.

"There is no doubt," the old chief said with somber deliberation, "that the other chiefs are trying to put one over on you. But when people are being deceitful, they open themselves up to deceit. You must use their tactics against them. Tell them that you share their concern over the bountifulness of your prodigy. Agree to a test. Not one that will take ten years to verify, for then you will be playing into their hand, but an immediate one. One that will allow everyone to see into the future together."

"And how will I do that?" asked the frustrated Orong.

"We all know that the waters of the river reflect the future. Assemble the entire tribe at the river's edge. Then carry your two children in your arms into the river. Whatever the waters reflect will be what the future brings."

Orong thought about that for a long time and finally said: "I'm not sure I'm ready for such a test."

The old chief laughed. "You must learn to believe more in your abilities in this area, and maybe a bit less in your invincible prowess as a warrior. It is time. Maybe your wives are right. You should relax and

spend more time at home with them. Who knows what will happen. Meanwhile, practice, practice, practice."

"Practice what?" asked Orong, a little disgusted with the old man's frankness.

"Practice standing on one foot while stirring the waters with the other. That way you will get many reflections, and it will look as if you will have many grandchildren and great grandchildren."

Orong smiled, finally understanding the ruse the old man was planning. He hurried away. But in his ears he could hear the old chief shouting after him: "Practice! Practice! Practice!" Orong practiced. His wives wondered at the amount of time he was spending alone in the river, waist deep in water.

When Orong was ready, he called the other chiefs to his clan house and asked them if the concern they had expressed at their last meeting was truly their one remaining reservation about making him king? They all looked at each other and nodded gravely. They had no choice. Orong was not a man to be trifled with. He then suggested a test of his virility. They agreed, with relief. "Take all the time you need," they offered generously. "No," replied Orong, "I mean an immediate test. But we must all agree to abide by the results." "What sort of immediate test?" they asked nervously. Orong outlined the test his old clan chief had suggested. The other chiefs asked a few questions to understand fully what he was proposing. They thought about that a bit, shared a few glances and relaxed. It seemed highly unlikely that the water would reflect anything but Orong and his two children.

Without giving the other chiefs time to think further about it, Orong assembled the entire tribe at the river's edge. He grabbed up his two children and slowly and deliberately walked into the river with them. The tribe waited, breathless. All they could see was Orong and his

two children reflected in the water. Orong stopped. Then, standing on one foot, he surreptitiously stirred up the waters with the other. As the chiefs and tribe watched, Orong and his two children's reflection changed to reveal five offspring from his two children, and nine from his five grandchildren.

Orong looked at each of the other chiefs defiantly. They could do nothing now but cheer him. The whole tribe joined in. At a lavish potlatch that Orong arranged for the occasion, the tribe crowned him king. Orong rewarded all the other chiefs with handsome gifts.

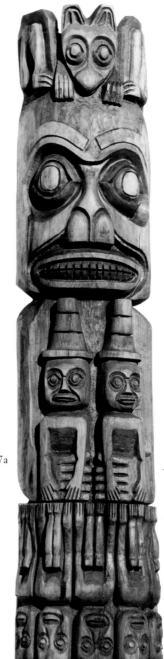

Fig. 17a

Fig. 17a: Reflection on Generations

The sculpture appears to be cut in two, with the bottom half shown upside-down. In fact, it captures the moment in time when the chief of the Bat clan has entered the river carrying his two children to see what their reflection will reveal. The line dividing the totem in two is the water line.

The bat that sits on the chief's head, its legs intertwined in the chief's ears, reveals that the chief belongs to the Bat clan. His great-grandchildren at the bottom of the totem are also shown as bats.

The importance of the chief and his children is shown by the number of rings, or skeels, on the children's hats.

Walnut, 20 inches by 90 inches, wall hung.

Fig. 17b: Detail of the Chief's Head

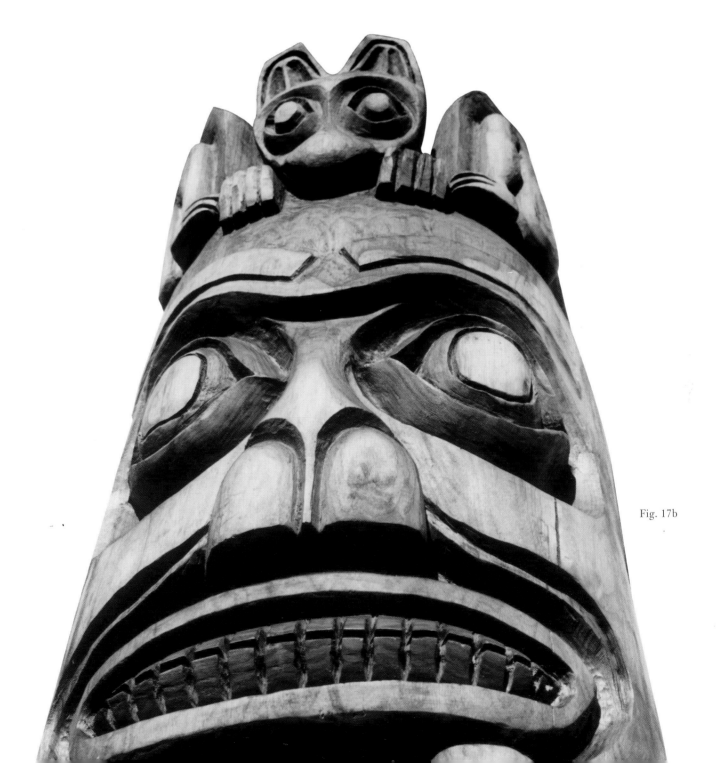

Fig. 17b

Bear Mother and Child
(How the Bears Married into the Wolf Clan)

A young Indian princess, the daughter of a chief of the Wolf clan, went into the woods with her friends to pick berries. When their baskets were full, they started for home, but the young princess slipped on some bear dung and spilled her entire basket. She cursed the bear for its lack of manners and told her friends to head home without her while she retrieved her berries.

The bear responsible, a young prince himself, overheard her ridiculing him and decided to teach her a lesson. He turned himself into a handsome young man and approached her with a kind smile. "May I help you pick up your berries, Miss?" he asked politely.

They joked together about how stupid bears were, and she sensed the young man had taken a shine to her. When they were finished picking up the berries, the young man suggested: "Maybe you'd like to come home with me? I'd like my family to meet you. It's not too far away."

He smiled so nicely and was so polite, she could not resist him. They turned in the other direction and walked for a while. He told her stories about his tribe, and an hour passed before she knew it. She

began getting tired and asked, "How much farther is it?" "Not far," he replied. But they continued to walk for a long time. She thought of turning back, but they had traveled so far, it no longer made sense to do that. Finally, she was so tired, she could walk no more. The young man said, "We are very near our camp now. Stay here and rest, and I'll rush ahead and tell my family that we're coming so that they can straighten up a little and prepare us some food."

He rushed home and told his family of bears what had happened and who he was bringing home with him. He asked them to turn themselves into people so that he could continue the ruse. Then he brought the princess home and introduced her to his entire family. She was a little surprised to find that they were, all of them—man, woman and child—wearing bearskin robes, but she was so excited about meeting the charming family of the handsome young man, she gave the matter no further thought.

She stayed with the family a few days and, to her complete surprise, the young man proposed that they get married. She gladly

accepted and said: "Let's go to my home now so that my family can meet you. Then we can all make preparations for the wedding."

But the young prince explained that it would be impossible, because his family was about to embark upon their annual hunt of the migrating caribou and that could not be postponed. He said they should get married now so that she could come along for the hunt, and when they got back, they could celebrate with her family.

Reluctant as she was to marry without involving her family, the Indian princess was so in love with the young man, she was afraid to let the opportunity slip away. So they got married and went off to the hunt. But the hunt took many months and by the time they got back to the bear camp she was in her final few months of pregnancy and could no longer move around easily. A visit to her family would have to wait until after the baby was born. That would be a second wonderful surprise for everyone back home, she thought.

When the princess gave birth, she finally understood that an elaborate trick had been played on her, because her child was half-bear and half-man. She felt very stupid for having allowed herself to have been taken in like that. Worse still, the bear family and her husband, the prince, who had treated her so nicely before, now treated her very badly. The pretense was gone, and she was being treated as a servant and an outsider. She gave some thought to taking her child and running back home, but she was too ashamed of what she had done to give it serious consideration. She was also uncertain about finding her way home, and she did not want to endanger her child. But in the end, she felt that she could not bring home a child that was half-man and half-bear and admit that she had let love blind her to all the rules she had been taught.

One day, as she was picking berries in the woods with her child and other members of the Bear clan, the Indian princess came upon

some members of her clan family, the wolves. They stopped in astonishment and called to her, but she quickly ran away with her child and the other bears.

Her clan members reported what they had seen to her father, the Chief of the Wolf clan. He concluded that she had been kidnapped and enslaved by the Bear clan. He summoned his two sons and told them to go into the woods and kill their sister's husband and half-bear child and bring her back home. Because she was the daughter of a chief, and theirs was a matrilineal society, she would one day inherit a great fortune from her brothers. She was also expected to produce children who would one day become chiefs. The chief told his sons to stay in the woods until they had done what he had told them and not to return without their sister.

After searching for many days, the two young men finally located the Bear clan. They circled the camp and waited until the young bear prince was alone, then jumped out of the woods and made ready to kill him. But the bear prince shouted: "Stop! We can fight and you may succeed in killing me, but I will kill at least one of you and maybe both. Instead, I will offer you a deal. I will let you kill me easily, but first you must let me turn my son into a full man, and then you must promise to take him and his mother back to your tribe and let him become your new chief when your old one has died."

The two brothers talked it over, and although it was not what their father, the chief, had told them they must do, it seemed like an altogether better arrangement. So they agreed to it. They killed the bear prince after he had changed his child into a human, and then they returned home with their sister and her child. The chief, their father, was at first displeased with his sons, but he was delighted to see his daughter again and immediately fell in love with his new grandson.

And that is how the Wolf clan and the Bear clan were united.

Lessons of the Story

This is a favorite story among Indian children and their parents because there are many lessons to be learned from it. The first is: Don't insult bears if you slip on their dung in the woods—which probably explains why Indian maidens have only good things to say about bears when walking in the woods.

The next lesson is to be wary of strangers, particularly handsome, smiling ones who offer you help. If something small seems odd to you—like everyone wearing a bearskin cloak—step back and think for a moment, because it is likely that something more serious is also wrong. Another lesson: do not to rush into opportunities because you think they will disappear tomorrow. In fact, the opportunity that looks good today may not look all that good tomorrow.

Perhaps the most important lesson is: don't marry far away from home—which is to say, don't marry among strangers. You will always remain an outsider, subject to ridicule. This is also a warning to children not to elope. There is good reason to take time to allow the two

families of the betrothed to get to know one another and check each other out before a marriage is agreed to.

The next lesson is: Even if you walk into a situation with your mind made up, keep your options open to unfolding opportunity. If you do, you might be able to come back with an even better deal—and with your life still intact. The next lesson is that: All life is sacred, even the life of a bear, or a child that is half-man and half-bear, and one should do everything to preserve it. But perhaps the most important lesson for children is: Even if you make a big mistake, don't be ashamed to tell your parents about it. Their love for you is greater than all the mistakes you can possibly make. And finally, children should know that their parents will give their own lives to ensure their children's future and the future of their children's progeny.

Figs. 18-22: Bear Mother and Child Totems

The Bear Mother and Child myth is prevalent among all the tribes of the Northwest. It is the story of an Indian princess who goes into the woods with her friends to pick berries, slips on some bear dung and makes a disparaging remark about bears. She is then courted and wed by by the young bear prince she has insulted. They produce a child that is half man and half bear, and only then does she realize that she has been duped.

When her brothers come to her rescue and try to kill her bear husband and half-breed child, a deal is struck whereby her husband gives up his life in exchange for her brothers' sparing the child's life and making it the tribe's eventual chief. This is only after the bear has changed the child to fully human form.

The bear that hears the insult from a distance and overtakes the human berry picker is obviously not a common animal but a spirit who was offended by the disrespect shown him. As a spirit, he has the ability to assume human form. This story is about the mystic union of two beings: one supernatural; the other human. The union results in the procreation of a child that belongs to both parents, being half bear and half human. It could be argued that the unaware woman herself becomes a spirit through the union. In any case, her offspring becomes the agent of good will between bear spirits and mankind, allowing bears to be slaughtered to feed their earthly protégés, but forcing man to show the proper respect to the bear spirit and to ensure the continued survival of the bear's progeny. Such motifs are known in Asian mythology and must have spread across the Bering Strait into North America.

I have carved five versions of the Bear Mother myth, inspired by different tribal interpretations—each of which I found unique.

In the first version, Figure 18, entitled Emerging Bear Child, the Bear Mother is shown converted into a bear spirit, but her child appears to be emerging from her in fully human form. This foreshadows the concluding portion of the myth. The original of this totem was a house post for the Bella-Coola tribe. A portion of the original is now at the American Museum of Natural History in New York City.

Fig. 18: Three views of the Bella-Coola tribe version of the Bear Mother myth. Walnut, 30 inches tall, freestanding.

Figures 19 and 20 are two interpretations of the Bear Mother myth by different clans of the Kwakiutl tribe. Figure 19 is of the Eagle clan (indicated by the eagle at the bottom of the totem). He is holding two copper shields, which indicate great wealth and status. Bear Mother is shown as half-bear, half-woman, although her emerging child appears to be all human. The original of this house post, collected in the 19th century, is at the National Museum of Canada.

Figure 20 is the Frog clan's interpretation of the Bear Mother myth, as indicated by the creature at the bottom of the totem who is half-woman, half-frog. She is also holding two copper shields. Bear Mother is here shown as half-bear, half-woman, although her child is fully human. To understand how the Frog clan made the Bear Mother myth part of their originating cosmology, see my Frog Mother totem and read its full story.

Figures 21 and 22 are my interpretation of a Haida Bear Mother house post. I carved the wood version (Figure 21) as a study for my larger Frog Mother totem. Figure 22 is a bronze casting of the wood original.

Fig. 19: A Kwakiutl tribe version of the Bear Mother myth carved for the Eagle clan. Walnut, 49 inches tall, freestanding.

Fig. 20: A second Kwakiutl tribe interpretation of the Bear Mother myth, this time carved for the Frog clan. Walnut, 52 inches tall, wall hung.

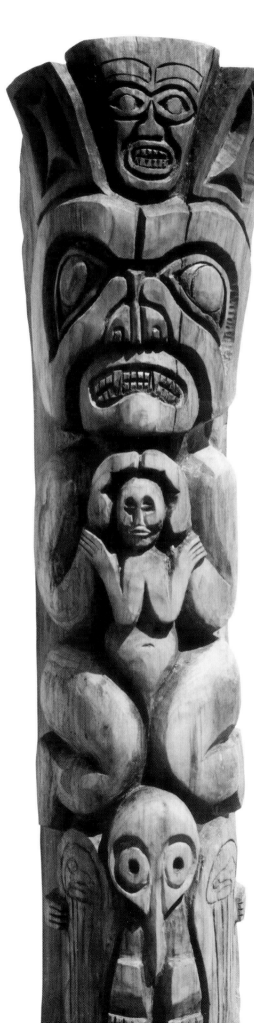

Fig. 19

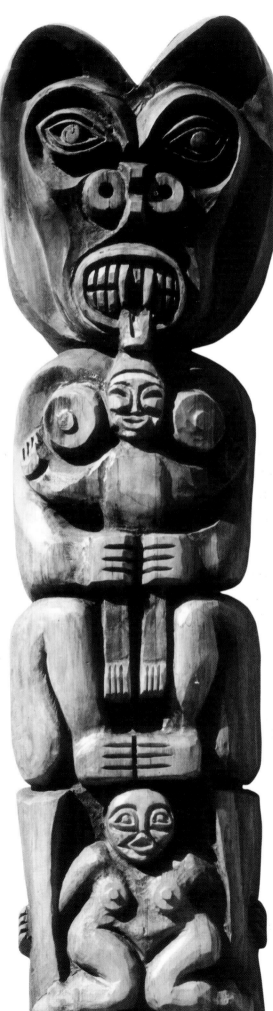

Fig. 20

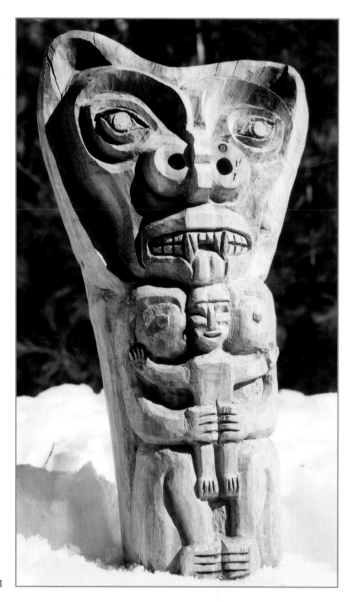

Fig. 21

Figs. 21 and 22: Two versions of a Haida tribe interpretation of the Bear Mother myth: the wood original and a bronze casting of it. Walnut (Fig. 21) and bronze (Fig. 22), 14 inches tall, freestanding.

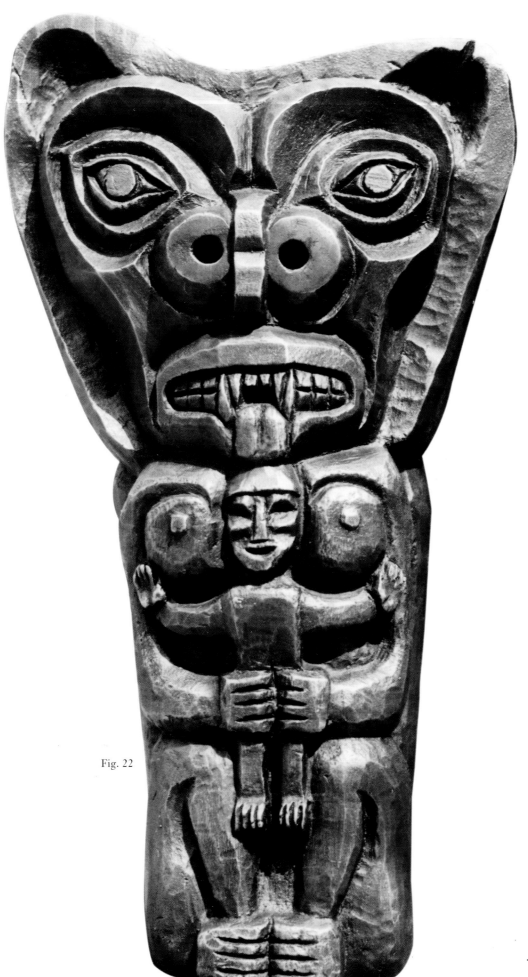

Fig. 22

Frog Mother
(How Mankind Learned to Respect
All Creatures)

A young Indian prince and his two friends were boasting about their many newly acquired skills. To demonstrate them, they decided to take a canoe and go fishing far from home and camp out overnight. As Indian parents like to encourage independence in their children, they gave their consent. But they reminded the boys to be careful and to remember to do all the things they had been taught. The boys agreed, without really listening to what they were being told.

Whether through skill or just dumb luck, by the end of the day the boys found themselves with a canoe full of trout. They picked a camp site and immediately set about making a fire to roast their trout. They had been canoeing and fishing all day and were famished. With no adults present, they did not follow their tribe's normal ritual of giving thanks to the Trout Mother for favoring them with so bountiful a catch.

As the boys were roasting their trout over the fire, a large frog leapt out of the woods and jumped onto the trout the prince was roasting. The prince and his friends were disgusted. The prince picked up a stick and pushed the frog off his trout. But the frog jumped right

back onto it. Again the prince drove him off. But the frog was persistent and jumped onto the trout again. This time the prince reached into his quiver for an arrow and speared the frog with it. He held the frog over the fire until it choked from the smoke and was partially burned. He then tossed it to the ground and said: "That'll teach you to be a pest!" His friends laughed. They finished roasting their trout and enjoyed a delicious meal.

That night the three boys slept uneasily. Something was bothering them, but they didn't know what it was. Their dreams turned violent and they awoke to a loud screaming. They opened their eyes to see a large woman looming over them. "My child, my child," she wailed. "What have you done with my child, the prince?" The boys had no idea who she was or what she was talking about. They huddled together in fear as the woman stalked around the camp looking for her child. She discovered the frog barely alive by the fire and examined it closely. To the boys' total amazement, she lifted it up by its legs and kissed its feet. Then she began crying and shaking uncontrollably. Long and bitter tears flowed from her eyes. She knew that the frog could not survive much

longer. Saddened by his own fate and the anguish of his mother, the dying frog caught her tears in his hands. The boys then realized that the frog they had tormented was the woman's son and prince, and that the wailing woman was the legendary Frog Mother.

Frog Mother then stood before the three boys and said: "My son was only trying to remind you of your obligation to give thanks to the mothers of all the creatures you hunt for food. Instead, you killed my son without reason and without need. Now, you too will suffer the same fate. Tomorrow, when you embark on your journey home, the first of you will die. Halfway home, the second will die. And when the third returns home and tells what happened, he too will die."

Events unfolded just as she predicted. The first boy died as the three got into the canoe. The second died halfway home. But when the prince arrived with his two dead companions, he would not tell his father, the chief, what had happened to them. He knew that once he did, he too would die.

The shaman, or medicine man, of the tribe examined the boys' dead bodies but could not find any physical wounds or outward signs of illness. The tribe began to panic from fear that some evil spirit was at work and that the same fate would soon befall them. The chief begged his son to tell what had happened to his companions, but he still refused. Tribe members began packing their belongings to move out of camp. The chief insisted that his son confess before the entire tribe dispersed in terror. The young prince then told his father what had happened, and as he finished, he passed away. A tribal council was held, and it was concluded that this was justifiable retribution by Frog Mother for the sins the boys had committed.

That night, as the entire tribe slept, Frog Mother appeared before them and began wailing. Everyone awoke in fright to hear her

lament over the loss of her son, the Frog Prince, and the generations that would have followed. As they watched in horror, she gathered up some burning logs and set fire to the entire camp. "You will all burn the way my son was burned," she cried. As people tried to flee, she drove them back into the flames. Before long, the entire village and its people were consumed.

The next morning, a young Indian maiden and her grandmother emerged from an adjoining cave that was used to initiate young girls who were menstruating for the first time. They looked for their house and family, but saw only the charred ruins of the camp and the smoldering bodies of the tribe. The grandmother had never seen anything like this. If a neighboring tribe had attacked, they would have taken prisoners to be used as slaves. They would also have taken away all the valuable possessions. But everything had been burned, and the tribe was still present, but dead. The grandmother feared that the same fate would soon befall the two of them. She began to cry: "We must run away, but I don't know where to run."

An owl who had witnessed everything flew down to the grandmother and the young girl. "Frog Mother has taken vengeance on your tribe for the wanton killing of her son," she told them. "Learn a lesson from this and respect all creatures, no matter how small. Come away with me quickly before she returns. Each of you hold onto one of my feet, and I will fly you to a new place and a new life." The young maiden and her grandmother held on for dear life while the owl flew them high and far to a distant land. It was a place where a chief and his wife were mourning the death of their young daughter. The owl dropped the young girl at the grave site and carried the grandmother to a nearby hill. "Stay here, watch and wait, but do nothing," the owl told her.

Before long, the chief and his wife came to the grave of their daughter to mourn her. When they saw the young girl sitting on the ground beside it, they assumed their daughter had been brought back to life. They hugged and kissed her and took her back to their tribe and shouted gleefully: "Our daughter has been brought back to life." The Northwest Indians believe that everyone is reincarnated after death, in the form of a newborn baby whose image is different. But neither the dead girl's two brothers nor the rest of the tribe were deceived. They realized that the chief and his wife were blinded by grief and their wish for the return of their daughter. So no one said anything for the moment, hoping that this new girl would dissipate the grief of the chief and his wife, and that with time, they would come to their senses and recognize this new girl as the stranger she was.

The chief and his wife raised the girl as their own daughter, lavishing more attention and possessions on her than they had on the daughter they had lost. The maiden, who was very thankful for her good fortune, treated everyone in the tribe with respect and honor, and gave generously of her time and possessions. She soon assumed a prominent position as the heir of the tribe. This was a matrilineal society—as is the case with most Northwest Indian tribes—which meant that her brothers would be leaving their wealth to her children rather than to their own. Because of her status, the chief's daughter was destined to marry the son of another chief and become a tribal matriarch.

One day, the two stepbrothers and the rest of the tribe decided to confront the chief's daughter about her deception. They were too frightened to do it in front of the chief and his wife, so they waited until they were gone on a long trip and the maiden was by herself. They brought her before a meeting of the entire tribe and accused her of

perpetrating a hoax. Her two brothers said they would never accept her children as their legitimate heirs. No one stood up to defend her.

Isolated and ashamed, the young girl fled into the forest in humiliation, leaving behind all her possessions and foregoing her future as a tribal mother. In the forest she encountered her grandmother, who had been watching her progress from afar. Elated by the initial course of events, the grandmother was now devastated by how it had all turned out. She said: "Our tribe's sin against Frog Mother and her son has come home to destroy our future too." In despair, the grandmother died. The girl was now completely on her own.

In the forest lived Bear Mother, the head of a new clan of hunters who had moved down from the north. Her son, a brave warrior, had not yet taken a wife. Seeing the young maiden and being impressed with her, Bear Mother sent her son, the young chief, to take her as his wife. They fell in love and married, and the maiden soon bore him a son who was half bear and half man.

Back at her village, the two stepbrothers soon came to regret what they had done. When the chief and his wife returned from their journey, they found their daughter gone and everyone ashamed to look them in the eye. They were devastated. No one would tell them what had happened—only that their daughter had fled into the woods. The chief's grief soon turned to anger. He called an assembly of the entire tribe and confronted his two sons. No one would dare lie to the chief when he demanded the truth. Experience had taught them that the chief knew how to distinguish truth from falsehood and would kill any person on the spot, even his own sons, if they dared lie to him. His two sons broke down and cried. They kneeled before their father and told him what they had done. They begged for mercy and explained that they had only sent the girl away because she was not their real sister. "You fools!" shouted

the chief. "You think I didn't know that? Who are you to tell me how the spirits work, and whether the girl who was brought to your dead sister's grave is not more sister to you than was your dead sister."

The chief allowed himself a few moments to regain his composure. "This is what you must now do," he informed his sons. "You must go into the woods and find your sister and bring her back to the village. And this is at penalty of your lives."

"It is too late," his sons told him. "She has been taken as a wife by the young bear prince, and she has borne him a son that is half bear and half man."

"Then that will be your punishment for your impetuous actions," said the chief. "Find your sister and bring her home with her newborn son, and upon my death, her son will be your new chief."

Upon her return to the village, the maiden took Frog as her clan name and made its image her crest.

In this way man developed an understanding with all creatures that allowed man to take their lives for his own survival, but to do it in a way that insured that the creatures would survive as well.

Reading the Totem

This totem pole (Figure 23a) is capped by three watchmen, or guardians. Located within an Indian village on the Northwest coast, such a pole would be positioned so that the middle watchman faced west, looking out to the sea. The watchmen on either side of him would look north and south, up and down the coast. As there are high, inaccessible mountains immediately to the east of these Indian villages, the three watchmen look only in the directions that visitors to their camp would likely come from. The watchmen are there to inform the chief of the

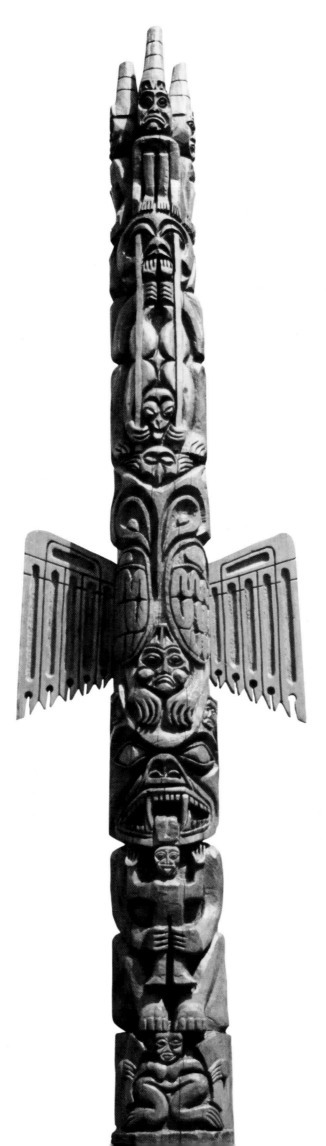

Fig. 23a: Frog Mother Totem

The tiered hats of the three Guardians on the top of the pole reflect their relative importance: the more tiers, the more important the chief who wears it. Tiers could only be added at a potlatch ceremony.

The Guardians face in the three directions that the village is open to attack from: the sea (west) and the shore up and down the coast (north and south).

The Frog Mother weeps over her dying son, the Prince, even as she devours him to keep him from being eaten by other animals.

The Frog Prince, dying from the burns and wounds inflicted by the Indian Prince, clings to his mother's tears.

The head of the Indian Prince who mortally wounded the Frog Prince seen as a skull flying off to the world of the dead.

The Owl who saved the Indian Maiden and her Grandmother by flying them away as they held onto his feet.

The head of the Grandmother of the Indian Maiden resting in the feet of the owl.

The Bear Prince who married the Indian Maid when she ran off into the woods after her stepbrothers spurned her right to succession.

The Son of the Bear Prince and the Indian Maid. The Son has been turned totally human, whereas he had been born half-bear, half-human.

The Princess who became the new matriarchal head of all the tribes shown as half frog, half woman. She holds two copper shields, which show her noble status and wealth.

Hemlock and pine, 20 feet, freestanding.

comings and goings of the tribe and of possible dangers from the arrival of strangers. These totem poles are usually set in front of houses that also face out to sea.

The tiered straw hats worn by the guardians may only be worn by tribal chieftains. The number of tiers, or skeels, on a hat indicates the relative importance of a chief. Each new tier can only be added at a potlatch ceremony. These celebrations occur every few years, usually following the death of an important chief. At these ceremonies, the new chief brings together his entire tribe and many chiefs from other tribes and distributes much of his wealth among them: food, blankets, weapons and tools. In exchange, the gift recipients accept the new chief's claims to territory, and to hunting, fishing and trading rights. It takes many years to put together the wealth and resources for a potlatch, and totems are often carved to commemorate such occasions. The totems serve as a record of the heritage, rights and claims of the chief and his successors.

There is concern among Indians that in taking the life of a creature, the "spirit" or "mother" of that creature will be alienated. This could prevent the future taking of such creatures and affect the survival of the tribe. So Indians were cautious about not appearing too greedy. There are stories about the complete disappearance of certain animals following an offense to their spirit or mother. This concern was only violated with the white man's arrival in the Northwest with his insatiable desire for otter fur—which then decimated the otter.

The respect for the life of all creatures and the penalty that must be paid for the wanton destruction of life is the main story behind the Frog Mother totem. It is the Owl who brings this important lesson home to man and allows his survival even after he has committed this inexcusable transgression. The head in the talons of the owl is that of the

grandmother of the young maiden. The maiden herself appears at the bottom of the totem, shown as half woman, half frog. In her arms she holds the copper shields, which protect and support her new tribe. The person for whom the totem is carved always appears at the bottom of the pole where they can most readily be seen. The so called "low man on a totem pole" is, in fact, the most important person on it. This totem would have been carved after the death of the chief who adopted the maiden, and only after she had become established as the new matriarch of the tribe.

The design of this totem is an amalgam of several totems from the late 1800s. I have composed it to tell the Frog Mother myth without recording all the forebears of particular tribes that are usually woven into totems. The myth as recorded above is a composite of those relayed by different Indians to various anthropologists and their Indian assistants.

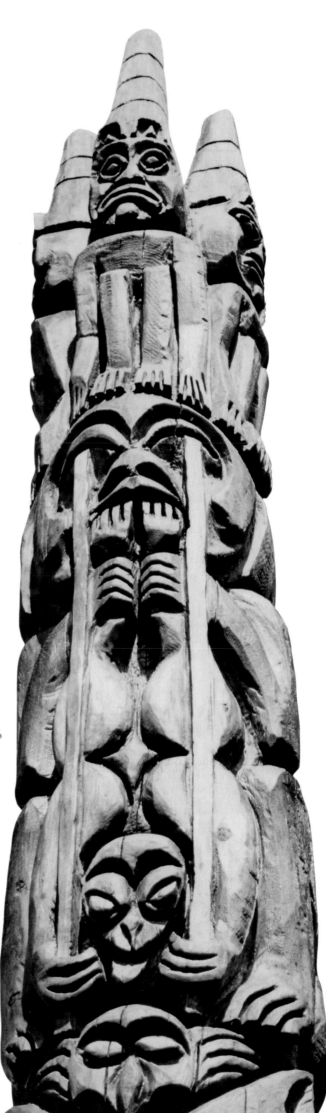

Fig. 23b

Secret Stories in the Art of the Northwest Indian

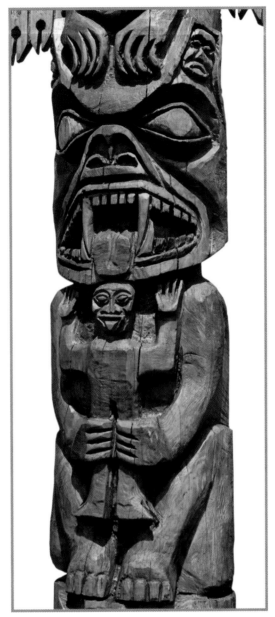

Fig. 23c

Fig. 23b: Detail of the Frog Mother totem showing the three guardians on top. Frog Mother, with tears streaming from her eyes, is holding her dying son. Her son, a prince, catches her tears in his hands.

Fig. 23c: Detail of the Bear Prince holding the son he has just changed from half-bear, half-man to fully human form.

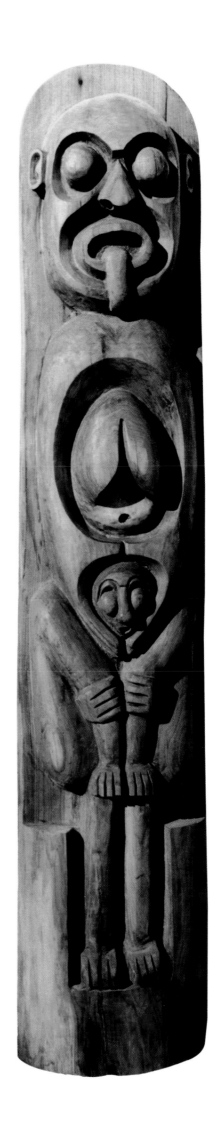

Fig. 24a: I Am Woman, Hear Me Roar!
(Chief's daughter astride her male consort)

This house post shows a woman sitting on the shoulders of a smaller man. She dwarfs him so completely that he cannot be seen at first. The relative size of people, as portrayed in Northwest sculpture, reflects their relative social importance. The circular element coming out of the woman's mouth and wrapping around her lower lip is either her tongue or a decorative ring. These rings were only worn by women of status, that is by either the wives or sisters of chiefs. In this sculpture it could be interpreted as being both: a ring to indicate her high status; and a tongue stuck out to indicate her contempt for her lowly husband whom she employs to portray her power as the eldest daughter of a mighty chief.

The woman's hands are wrapped around the man's head. Because of where the man's head is positioned, it is possible to interpret his nose and cheeks as being her equivalent of male sexual organs (Fig. 24b. She borrows his face to make herself male.) The man is standing in a pit to allow the woman to more readily climb upon his shoulders.

The original on which this is based is in the Royal British Columbia Museum in Victoria, B.C., Canada.

Walnut, 90 inches tall, wall hung.

I Am Woman, Hear Me Roar! (A Chief's Sister Sits Astride Her Male Consort)

Succession in Northwest Indian society was matrilineal: the wealth of the male head of the family (the chief) was handed down to his oldest sister's eldest son. A woman's dependence upon, and loyalty to, her husband was not, as a consequence, as strong as in patriarchal Western societies. Indian women, therefore, enjoyed a degree of independence from their husbands not shared by women in Western society. Among the Northwest Indians, a woman's primary loyalty was to her oldest brother. Her oldest male child's primary loyalty was, consequently, to his oldest uncle.

This house post portrays a woman sitting on the shoulders of a comparatively smaller man. She dwarfs him so completely that he cannot be seen at first. The relative sizes of people portrayed in Northwest sculpture reflects their relative social importance. The woman's hands are wrapped around the man's head. His head is placed so that it is possible to interpret his nose and cheeks as forming the equivalent of her male sexual organs. (In other words, she has borrowed his face to make herself a man.)

The man is standing in a pit to allow the woman to climb more readily upon his shoulders. This suggests that her mounting of him in this way was a common occurrence. After all, why go to the trouble of digging a pit if you are only going to use it once? They probably walked around together within tribal territory frequently in this fashion.

There is some debate whether the man was her slave (Northwest Indians had slaves) or her husband of a lower rank. My interpretation is that he was her husband. Why make a statement about a slave's inferiority, when it is already known to all? If you are going to record and symbolize a situation through the expensive medium of sculpture, it is because you want to make a statement of some consequence.

The object protruding from the woman's mouth is either her tongue or a decorative ring. Such rings were worn only by women of rank: the wives or sisters of chiefs. In this sculpture the circular element can be interpreted as both: a ring, to indicate her high status; and a tongue, to indicate her contempt for her lowly husband.

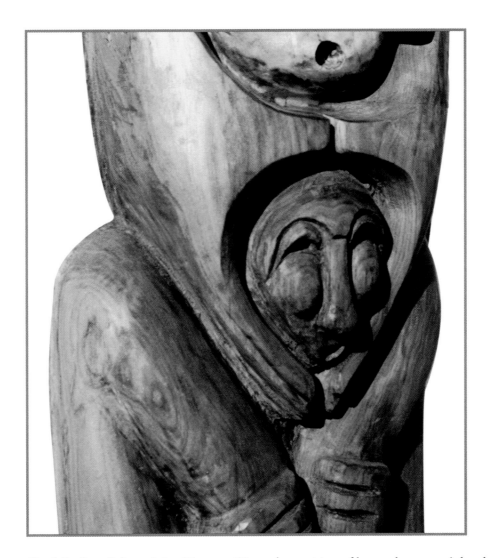

Fig. 24b: Detail from I Am Woman. Given the position of her male consort's head, his nose and his cheeks may be read as the equivalent of her male sexual organs.

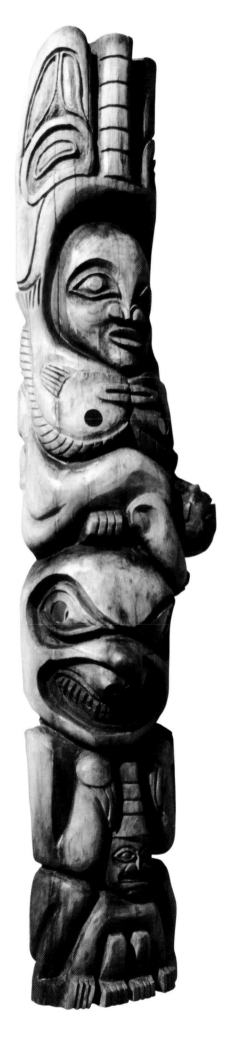

Fig. 25a: The Salmon-Eater Tragedy Totem

This totem is a record of an intended union between two clans that could not take place because of the untimely death of one of the betrothed children.

The two clans, the Salmon-Eaters and the Bears, were both wealthy: the Bears had acquired their wealth through the hunting of land animals; the Salmon-Eaters were fishermen of salmon and whale who controlled the offshore Pacific waters with their long boats. They dealt in dried fish and the whale oil for lamps, which was coveted by all tribes.

The proposed union would have resolved a territorial dispute and consolidated the wealth of the two tribes. But the princess drowned while gathering the abalone shells that would have been used to decorate her wedding gown.

The totem shows the drowned princess being held in the arms of her despairing mother. That her mother is an important clan matriarch is made evident by the many rings on her straw hat. Her breasts also form the salmon of her clan name. Such double use of form is common in Northwest Indian art.

The disappointed patriarch of the Bear clan is shown below being very protective of his son, who also wears a straw hat with many rings.

The notorious abalone shells that gave rise to the accident are used here to make the eyes of the fish and the bear.

Walnut, 100 inches high, wall hung.

The Salmon-Eater Tragedy
(How the Salmon-Eaters Replaced the Grizzlies)

The great flood that engulfed southern Alaska washed out the entire village of the Gitrhawn people. (They were called Gitrhawn, or Salmon-Eaters, because salmon was their main diet.) The entire tribe put their belongings into twenty large dugout canoes and headed south along the coast looking for a drier place to settle. The mists and foam brought by the flood blanketed everything. It was impossible to see where they were going. They made their way south by paddling toward the lighter portions of the mists.

They had been traveling hard for many months when the mists finally lifted, and they emerged the foam. The tribe found itself in a large, sunny bay. Its protected waters were calm and teeming with ocean life: fish, mollusks, sea birds, otters and even the occasional whale. Because the Salmon-Eaters earned their livelihood from the sea, this new place was paradise for them. There was only one problem, and it was not a small one: the bay was already inhabited by another people. This was the Grizzly Bear tribe.

The Salmon-Eaters took temporary refuge on the opposite side of the bay from the Grizzlies. Both tribes eyed each other suspiciously from a distance. They were equally large in number and equally wary, so it was impossible for either side to launch a surprise attack. After a few days, the Salmon-Eaters decided that they liked the bay so much, they would fight the Grizzly Bears for the rights to it.

The Salmon-Eater chief, a great warrior and a man not known for his patience, sent his older brother on a mission of peace to the Grizzly Bears, but his real purpose was to spy on them and find out how strong they were. When his brother returned, he said: "Don't bother preparing for war. The Grizzly Bears do not live off the sea; they live off the land. They hunt deer, goats and other land creatures—and they eat berries." This last was said with great disdain as the Salmon-Eaters thought themselves the bravest of all West Coast Indians because they hunted the great whale. The Salmon-Eaters also ate their fish so ripe (which is to say aged) that no other tribe would go near them after a feast.

"The bay is many miles long," continued the chief's brother, "and as we are not competing for the same food, there is room enough for both our villages: the Gitrhawn on one side of the bay and the Grizzlies on the other. I have talked this solution over with the chief of the Grizzlies, and he seems willing to accept it."

"Good," said the chief. "That was easier than I expected."

"But...They don't trust us any more than we do them. They are concerned that we will multiply in great numbers and take the bay away from them."

"He is no fool, this Grizzly chief. What is his name, and what does he propose?" replied the chief.

"His name is Ka'it, meaning cautious one, and the way he would like to resolve this problem—and you are not going to like this—is to have his sister's son marry Salarhkous, your older sister's eldest daughter."

Now Salarhkous was not only very precious to the chief, she and her future husband would be inheriting much of the chief's wealth. The chief was saving Salarhkous for marriage with the son of a very important Indian chief to cement the relationship between both the two tribes. He did not think the Grizzlies worthy of Salarhkous.

"And how did this Ka'it learn so much about us?" demanded the chief. "I did not send you there to negotiate a peace, I sent you to spy on them so we could prepare for war. What foolishness is this? Don't you have the stomach for battle? Is that your problem? Is that why you have come back with this ridiculous proposal for peace?"

But the chief's brother knew how to deal with him. "Our people are exhausted from the trauma of the flood and the long journey we have just completed," he said. "No one else in our tribe is as brave or as strong as you are. The Grizzlies have been at rest for a long time. They are fat and full of self-assurance. This peace, however temporary, will give us a chance to get our strength back. You can always go to battle later, if you want to."

"The danger," replied the chief, "is that if we give the Grizzlies time, they will be able to prepare themselves for an attack. And with time, our two tribes will get to know each other and become friendly, and we will lose our will to attack."

But in the end the chief knew that his brother was right. So he sent word to Ka'it, Chief of the Grizzlies, to send the uncles of the bridegroom to collect the bride. To display the wealth and skills of the Salmon-Eaters, the Chief dressed Salarhkous in his prized possession, a

beautifully made robe of young sea otter. Otter is the most precious of all furs because it is dense, lustrous, appears to flow like water and is lightweight, but still very warm. It is the most desired of trading items. Salarhkous, who was already beautiful, looked even more splendid in the otter robe.

Salarhkous was brought to the Grizzlies' camp and introduced to her bridegroom. As tradition demands, the couple retired for the night together so that their impending marriage could be consummated. In a few days time the ceremonial wedding and festivities would take place. Both tribes were now preparing food, costumes, songs and dances for it.

But instead of asking his bride to join him in bed, the groom directed her to stand beside the bed, hold up a lighted torch and let it burn all night long. He slept soundly while she stood bedside watching the torch slowly burn down to her hand. Before the flame could reach her, she took off her magnificent otter robe and wrapped it around her hand. The flame burned through her robe until all of it was consumed.

In the morning, when the groom's relatives visited the couple, they found the bride dressed only in her undergarments. A heap of ashes was all that remained of the wondrous robe. The groom's relatives chastised him for not taking his wife to bed and forcing her to do such a foolish thing. They warned him of the dangers that would come from this. But the young man said he had a reason for his actions and was not afraid. The groom's uncle, Chief Ka'it, offered the bride one of his own expensive robes, made from bear skin, but she refused it.

When the Salmon-Eaters began bringing food over for the wedding feast, they visited Salarhkous and found her unclothed and in a state of distress. She told them what had happened. The Salmon-Eaters returned to their camp and told the chief what Salarhkous had been

forced to do, and about the destruction of the tribe's most expensive robe and symbol of wealth. The chief flew into a rage and instructed everyone to prepare for war. But before they could launch their canoes, the young groom, unaccompanied by any other members of his tribe, rowed up and asked to speak to the chief to explain his actions.

This was very brave of the groom, because given what he had done, he could have been killed by any of the Salmon-Eater warriors, and it would have been seen as justified in the eyes of both tribes. His show of bravery was admired, and instead of being killed on the spot, he was dragged before the chief and the elders of the tribe.

The chief studied the young groom for a while and said: "You have done an unspeakable thing. You have insulted me, caused Salarhkous great pain and have maligned the entire Salmon-Eater people. You have also forced Salarhkous to destroy one of our tribe's most sacred possessions. What do you have to say for yourself before we kill you?"

The groom dared not move. He looked up at the chief and said: "Forgive me for what I have done, it was my decision and not my tribe's. My uncle, our tribe's chief, has told me that he disassociates himself from my actions, and that, as far as he is concerned, I am a dead man. It is true I may appear headstrong and willful. But I assure you that I am neither. I did this because, like you, I come from a very proud and powerful people. And although I am thankful for my bride's wealth and the power of your clan, I resent the notion that this wealth, as symbolized in the otter robe, is important to me. I prefer to make my own wealth, which my bride and I will proudly share. That is why I had to destroy her robe. I did not want it to remind me continually of her wealth.

"If my bride is willing to assist me, I will make her a new robe of the finest otter skins I have. To show that her skills are also important

to me, we will decorate that robe with the shells of abalone that she will dive for and collect. Together, from our two contributions, this new robe will symbolize the unity of our tribes and our own new wealth."

The young man had spoken well. The chief was surprised. He had expected rudeness and defiance. Instead of issuing a death sentence, the chief asked that the young man be removed from his house so that he could discuss his fate with the assembled tribal elders.

All the elders agreed that the young man had spoken well, and that they understood his reasoning, even if they did not agree with it. One elder reminded everyone that this was an arranged marriage, and its purpose was to unite two powerful tribes and by so doing avoid conflicts, but by his willful action, the young man had ensured the opposite. Another elder said that arranged marriages do involve the exchange of important gifts, and the young man should have known that, and known how to accept such gifts gracefully. And a third said that the young man could one day have become the chief of both tribes. Instead, he faced death. Nevertheless, the young man showed that he has great pride and courage: first by refusing to accept inherited wealth; second by coming over alone to explain himself, and third by taking sole responsibility for his actions.

The chief listened to all the arguments and said: "As my brother knows, I had serious doubts about this marriage proposal from the start. I have even more doubts now. We do not see things with the same eyes, the Grizzly people and us. Maybe we should be thankful to the young man for pointing this out to us early, so that we will be saved greater disappointments later. The young man has made some unforgivable mistakes. Now he proposes a new and even stranger course of action to us. Are we to take the advice of a young man who has shown no knowledge of or respect for tribal ways, and does not have the good

sense to accept things as they are until he can grow up to understand them? No, I will not do what you advise," he told the tribal elders. "His uncle, the chief, has sent him here for no other reason than for us to put him to death. That is why he is unaccompanied. His tribe knows the insult and injury he has done to us in their name; and they hope that with the young man's death, things will go better between us. We now must do what they expect and what we know is necessary. If we do not kill the young man, then we must immediately go to war with the Grizzlies."

The chief's elder brother spoke up quickly before anyone could give their accord. "You say that we must either kill the young man or do battle with the Grizzlies, but there is another course of action: we could give the young man a chance to show if he is as skilled with his hands as he is with his words. Let us see if he can fashion a fine robe from his catch of otters' skins—one as wondrous as the robe he destroyed. Let us see how skillfully he can decorate that robe with the abalone shells that Salarhkous finds for him. All of this must be with Salarhkous' approval, of course, for the insult to her is the most grave of all. And I think it would be wise of us to keep the marriage from being consummated until the robe is finished and it meets with our approval."

These last two sentences convinced everyone, because the matter was now placed in Salarhkous' hands, where it rightly belonged. An elder was dispatched to ask Salarhkous. When, to everyone's surprise, Salarhkous agreed, the whole tribe breathed a sigh of relief. The chief, however, was skeptical. He did not stop his preparations for battle.

The young man began to sort his otter pelts, and Salarhkous began diving for abalone. She was lucky to obtain a few good specimens on her first dive. This was a good omen. But on her second dive her foot became snared in seaweed and she could not pull it free. She drowned before the other divers could reach her.

Drowning is the form of death most feared by the Northwest Indians, because a body that has drowned is usually lost at sea and cannot be cremated. This means the dead person's ghost and spirits will not be able to reach the world of the dead and the deceased will not be reincarnated. On orders of the chief, divers were sent down again and again to try to untangle Salarhkous' dead body from the seaweed. At last, they succeeded and brought her up.

They carried her ashore and brought her to her mother, the chief's eldest sister. The tribe gathered quickly and looked on in hushed silence. Even the eternally yapping dogs went quiet. Her mother cradled her in her arms and began shaking violently from a crying that could find no voice. She carried Salarhkous to her brother, the chief. When he saw Salarhkous dead, the devastation that was his sister's face and the intent look of the tribe behind her, he gave a quiet order to assemble the elders along with the chief warriors.

This time he took no counsel. He told everyone that they had been foolish to think that anything good could come from such an arrangement. Before word of the death of Salarhkous could get back to the Grizzly tribe, the chief said they should attack. Although it was unusual for the Salmon-Eaters to attack another tribe while they slept, this situation warranted it, because the Grizzlies had betrayed a trust.

That night the Salmon-Eaters launched three canoes of warriors. They stole up to the Grizzly's camp and, on a signal from the chief, entered the long houses together and slaughtered everyone. The chief himself killed over half the warriors with his carved stone club.

Fig. 25b: Detail of Salmon-Eater Tragedy, Showing the Drowned Princess

The head and arms of the drowned Salmon-Eater clan daughter are shown above. She hangs upside down, her eyes shut. One arm hangs down below her head, the other arm rests by the side of her.

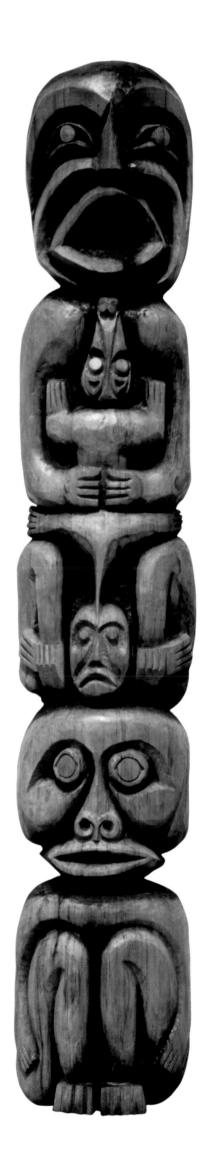

Fig. 26: Speaker's House Post

Despite its simplicity, there is a certain gentleness by which creatures within the totem touch and hold each other. The lines used to compose this totem pay more than lip-service to geometrical forms.

Walnut, 84 inches, wall hung.

Speaker's House Post

The original of this carving was a Kwakiutl house post that stood as a support column within a ceremonial house on Hope Island. It was described by the anthropologist Dr. Franz Boaz during his visit there in 1888.

The house post stood near the end walls of the long house and was one of the supports for the main beam. It faced toward the room.

The chief belonged to the Possum clan, indicated by the creature he holds to his chest.

To address his clansmen, the chief stood on a ladder behind the house post and talked through the mouth of the upper creature.

MASKS

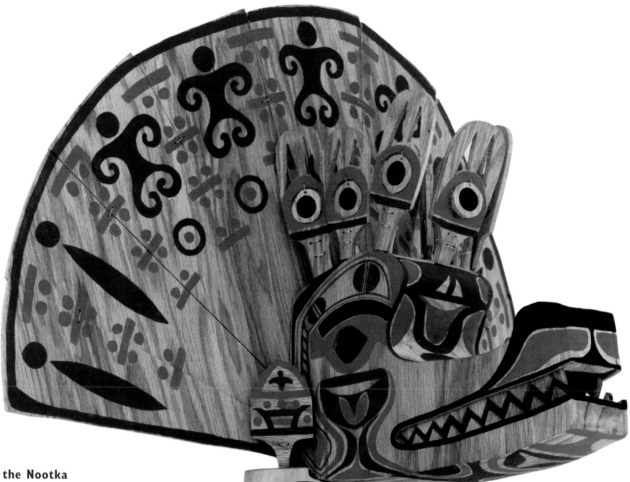

Fig. 27: Wolf Mask of the Nootka

This ceremonial mask of the Nootka tribe (now called Nuu-Chal-Nuth) is a crest of the Wolf Clan within that tribe. It celebrates the time when the Nootka were starving because their food supply from the sea had dried up and Wolf showed them how to hunt and live off land-based creatures.

The wolf's head is shown protruding forward above the face mask. A facsimile of feathers stick out of the wolf's head. The boards behind the wolf's head are themselves a form of feathers.

The face mask is too large to allow the wearer to see out through the mask's eyes, so cuts are made for viewing below the eyes.

The wolf's head is hollow. Very thin woods had to be used in making this headdress or it would have become too heavy to wear.

Various woods, painted, 27 by 33 inches.

The Origin of the Wolf Clan
(How the Wolf and Man Reached an Accord)

The Nootka, who occupy the west coast of Vancouver Island just north of Victoria, mostly live off the sea. Salmon is their most common food. And when these fish return to their home rivers to spawn, enough are taken in a few days to ensure a plentiful food supply for the entire winter.

One year, the salmon did not return to their traditional spawning grounds. The Nootka waited, but with no result. They were not the only ones disappointed: the bears, birds and mollusks who also fattened up on the salmon for the winter were equally deprived. It was too late to make other provisions. That winter, the Nootka people began to starve. They looked everywhere, but did not know how to find other food. All the creatures who lived at the edge of the sea had become dependent on the salmon run, and when that didn't happen, they all faced starvation.

Every day during these bad times, the tribe heard wolves howling in the woods. They thought that the wolves, like them, were crying from hunger, and that they meant to come into their village and eat them. But after a while they recognized the wolf cry to be the howl

of a single creature. The tribe decided to send out its most experienced hunter to investigate.

When the hunter entered the woods some distance from the village, he came upon a huge wolf pacing back and forth. From its sheer size, the hunter could see that this wolf must be the leader of his pack, but, strangely, there were no other pack members near him. The hunter came closer, and he could hear the wolf whining between howls. He approached cautiously, sensing from the wolf's strangely submissive attitude that he needed help.

"What is it, my brother?" the hunter asked. "What tragedy has befallen you, that you moan so pitifully?"

The wolf growled, warning the hunter not to come any closer. The hunter sat down and opened both hands, extending them, palms up, to the wolf's open mouth. This showed the wolf that he held no weapons and that the the hunter trusted the wolf not to rush forward and bite his hands. The wolf followed his lead and sat down, facing the hunter.

"Come to me, my brother," said the hunter, "so that I can see what ails you."

The wolf rose and moved slowly toward the hunter, never shutting his open jaws. The hunter sensed that something was wrong with the wolf's mouth.

"Do not bite me, my brother," said the hunter, "for I mean to look inside your mouth." He took hold of the wolf's jaws with both hands and looked down into the wolf's throat. He saw that a broken deer bone had lodged there, preventing the wolf from eating, and that this was causing him great pain.

"This will hurt you, brother," the hunter explained, "but afterwards you will feel much better." Carefully, he put his fingers down

the wolf's throat, forcing the jagged edges of the bone to come free. He pulled the bone out as gently as he could, and the wolf emitted a low growl. Blood flowed from the wound the jagged bone had made.

As the wolf tasted his own blood, he growled angrily. But the hunter quickly showed him the bloodied deer bone, and the wolf relaxed. So did the hunter. The wolf swallowed a few times and realized that he could now close his mouth. The pain was diminishing. The wolf jumped up, licked the hunter's face and let out a great howl. He disappeared into the woods.

A few days later the starving villagers heard the howling of the great wolf again. "That stupid wolf of yours has got another bone stuck in his throat," they said to the hunter. "If only we had food enough to worry about it sticking in our throats."

The hunter went out to see the wolf again and found him standing over a large, freshly killed buck. As the hunter stepped forward, the wolf stepped back from his kill, slowly wagging his tail. Under such circumstances, a wolf would normally growl and defend his prize. The hunter understood that the wolf meant for him to have the deer. He took it back to the village, and everyone had a feast.

Every day for two weeks, the wolf brought the hunter another catch from the woods: rabbits, turkeys and mountain goat. Before long, the threat of hunger was gone, and the people of the village were healthy again. It was then that the Nootka learned to supplement their food from the sea by taking food from the forest and neighboring mountains. The wolf had taught them to hunt as wolves do.

In tribute to the wolf, the tribe took the wolf's name and crest as its own. After that, all Northwest Indian tribes were divided into two fraternities: the wolf clan and the eagle clan—honoring the two most powerful hunters of the animal kingdom.

Mortuary Poles and Masks

The disposal of the dead, particularly the bodies of important chiefs, was the most demanding and elaborate of rituals engaged in by the Indians of the Northwest. Death concerned the transfer of one's ghost and two spirits from a life on earth to a life in the village of the dead.

Only important chiefs were given a funeral ceremony that lasted as long as eight days and culminated, a year later, in a potlatch. Such chiefs controlled all of their tribe's wealth, and it was at these funeral ceremonies that this wealth was distributed. Hence, the critical importance of the burial rituals to Northwest Indian life.

Upon a chief's death, his entire house was decorated with his crests and masks. His body was then dressed in his most prestigious hats and garments, and positioned for lying-in-state. The areas of the house that surrounded the chief's body were then assigned as sitting places to people of different rank, both from within the tribe and from without.

The funeral ceremony itself had to be prepared by the chief's clan-opposites. Once cleaned, the chief's body was cloaked in his most elaborate Chilkat blanket and his head crowned by his many-skeeled hat.

His face was then painted to hide its death pallor. The chief was propped up into a sitting position, and his eyes opened to make him look as if he were still alive. His body was surrounded on all sides by his most important clan masks and artifacts.

The lying-in-state, which took from four to eight days, involved dancing, singing and speechmaking. All of this was an elaborate form of negotiation for the chief's possessions. The chief's body was then removed from the family house for cremation or boxing. A year later, a potlatch was held in which the actual wealth, power, privileges, crests, names, songs and dances owned by the deceased chief were distributed among the living.

Two types of totem poles emerged from these burial ceremonies: the memorial pole and the mortuary pole. For very important chiefs, the ones who gave the tribe its name, the distribution of wealth was memorialized in a totem pole that was raised at the occasion of the potlatch. Memorial poles, as these have come to be called, recorded the family crests and history, and the privileges of the departed chief. They also indicated how his wealth had been distributed among the living

members of his tribe and to important outsiders whose claims had to be satisfied. In memorializing the distribution of rights, privileges and wealth, the memorial post served as a form of physical contract.

The journey from the world of the living to the spirit world of the dead took different forms for different tribes, depending on where the spirit world was thought to be located. For some tribes, the spirit world was located in an underworld beneath the sea. For others, the spirit world was located where the mountains met the sky.

The process by which the spirits migrated to the world of the dead was learned by questioning people who had died but returned to life during their wake. It was thought that these people had actually passed away, rather than collapsed into a deep coma. As they all told of similar experiences, it was assumed that all they had to say was actually what transpired during the wake and before the body was put on a pyre and burned or placed into a mortuary box.

One of the purposes of the lying-in-state was to allow the body to be ritually purified before it entered the spirit world. Cremation could only take place once this journey was completed. For lesser chiefs and nobility, the lying-in-state lasted four days; for superior chiefs, it lasted eight. As superior chiefs were supposed to be purer to start with, it is not clear why they required an additional four days of cleansing. It is said these days were needed because the journey from earth to sky was more taxing for an important chief. The rulers of the various worlds he had to pass through on his journey from earth to the village of the spirits were more envious of his position and attainments and endeavored to exact a higher price for his passage.

A practical reason for the additional days is that chiefs from distant tribes wanted to be present at the lying-in-state and cremation of an important chief. More time was needed to inform them and allow

them to prepare for and make their journey. Luckily, as superior chiefs were believed to be purer than others, their bodies were said not to decompose as quickly.

At the completion of the wake, the dead were removed through a hole in the dwelling, rather than an existing door. This was either a hole cut in a rear wall adjacent to where the cremation of the body took place, or through the dwelling's existing smoke hole. There is, of course, the obvious parallel of the dead being removed from this world through a hole in the body of a dwelling just as a newborn infant is brought into the world through a hole in its mother's body. But the main reason for removing the body through a special hole was not to contaminate, or spook, the dwelling's existing doors. The dead and their ghosts, however much they might be revered, were still perceived as being vengeful and anxious to take someone back with them to the spirit world—particularly children and close family members. This is why children were kept a good distance from the dead.

The Northwest Indians believed that, upon death, the body had a ghost and two spirits that hovered above it. The ghost remained very close to the body, and while the body was still within the dwelling, the ghost could be experienced as a facial tickle by relatives. The ghost, as different from the deceased's two spirits, was said to remain with the body forever, even after it was cremated and the two spirits had been freed to make their way to the village of the dead. After a year, one of these two spirits would return to earth to be reincarnated into a newborn child, conceived by a woman of the deceased's choosing. That child would be given the name of the departed chief and treated with much respect—that is until it began to become abusive of its inherited name and status, or until the influence of the dead chief upon the living had begun to wear off.

There were, among the tribes of the Northwest Indians, two basic means of disposing of the remains of the deceased: the first was through cremation; the second, through the exposure of the body in a partially enclosed and raised box. In the first method, fire consumed the soft, wet and temporary tissue of the dead. In the second, these tissues were removed by Raven who picked the flesh off the body of the deceased. These soft tissues were not considered sacred.

The Northwest Indians saw all living creatures as being composed of two types of matter: first, the dry, hard and permanent matter consisting of the skull and the major bones of the body; and second, the intervening wet, soft and temporary skin, flesh and organs which, at death, had to be removed and separated from the hard and dry remains. The bones, or hard matter, would then receive permanent enclosure and placement in a cemetery or in a box erected on top of a pole placed beside the family house.

Upon the death of a chief, a tall pole was erected to memorialize him and his descendants. This pole was accompanied by a smaller pole with a box on top of it that held his remains. This was called a mortuary pole.

Haida mortuary poles were usually located near the house of the deceased, while Tlingit poles were located either near the house or in a separate cemetery. Both these poles were decorated with family crests or with imagery of death. Common images of death among the Haida Indians were the mountain goat head (with horns) and the hawk that swallows its own beak.

Local grave sites were also decorated with imagery, sometimes of the deceased and sometimes of watchmen. These sites were considered the physical embodiment of the distant village of the dead, and the site's care or neglect reflected the reverence felt by the deceased's

relatives. The status of the deceased in the afterworld was thought to depend on the food offered up to the deceased as burnt offerings by their living kin.

I have carved and painted three objects that deal with the transformation of the spirits from this world to the next:

Mask of Passage to the Spirit World: This circular mask describes the worlds that the spirits must pass through on the way to the afterworld in the sky.

Mask of Transformations: This mask describes the various stages of life and its transformations after death.

Death and Reincarnation: This is my design for the frontal portion of a mortuary box that would be placed on top of a pole to house the full remains of a chief.

Mask of Passage to the Spirit World

The ghost and the two spirits that people leave behind behave differently. The ghost remains with the body and its bones forever. But the two spirits find themselves released into the sea that lies in front of the tribal village. This release is akin to the release of every child into the world with the amniotic fluid. The sea is thought to be a vast realm that encompasses the entire earth, spreading under the land as well.

Each of the creatures in my mask represents the various zones that spirits must pass through after death to arrive at the afterworld. First, they enter the underworld of the sea, which is ruled by Killer Whale. Then, they make their way into the swamps ruled by Frog. From there, they clamber onto land, ruled by Man. Finally, they make their way up the mountains to the sky, which is ruled by Raven. (Some will see in this journey a similarity to the evolutionary climb of primitive creatures onto the land.) One of the two spirits will remain in the spirit

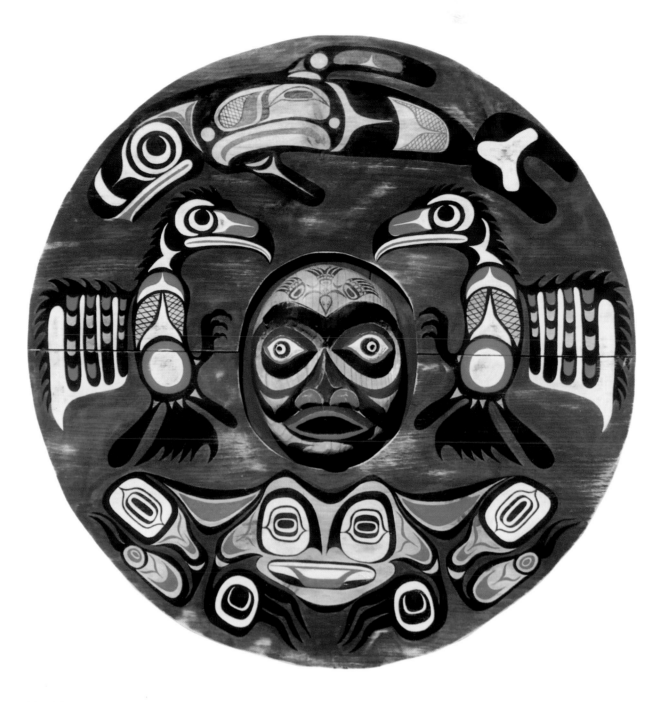

Fig. 28: Mask of Passage to the Spirit World

A mask like this one is used by dancers at the wakes of important chiefs. The dancer holds the mask up over his face using the two wooden handles affixed to the back.

Each creature in this mask represents one of the four zones on earth that spirits of the recently departed must pass through to arrive at the spirit world.

My inspiration for this mask was produced in the 19th century by the Bella-Coola tribe located at Naxalk. Paint on various woods, 40 inches in diameter.

world forever, while the other will be reincarnated into a newborn child in about a year's time.

Of the four worlds the spirits must pass through (sea, swamp, land and sky), the journey through the sea is considered the most taxing. The sea is ruled by Killer Whale, the most powerful of the sea creatures. He is more powerful than Whale (who is larger but more gentle) and more powerful still than Shark (who, while not as large, is more vicious and stupid). Killer Whale is both deliberate and deadly, and is emulated for that reason. Because Killer Whale is a mammal, he is thought to have a superior mentality to that of the shark.

The Killer Whale chief knows the social status of each person who dies and must pass through his realm. The more important the personage, the higher the price Killer Whale asks for his passage. In fact, Killer Whale's price can be so ridiculously high that important chiefs are said to hesitate in paying it. This fee must be paid by the chief's relatives while he is still lying in state. Gifts of food and various articles are thrown into the fire by the deceased's relatives during the lying-in-state ceremony to pay for this passage. Even slaves are killed to pave the way for the chief to the spirit world. Gifts of blankets are made, valuable copper shields are broken and thrown into the fire, all as payment to Killer Whale.

Once Killer Whale grants passage, and this may take a few days, the rest of the journey is more assured, but not necessarily less taxing. The two spirits must now pull themselves out of the sea and crawl through the swamp dominated by Frog Mother. This is the slimy, primordial world of the tidal basins. It consists of mud and the decaying matter of plants and animals. But it is more an unpleasant journey than a forbidding one.

Once the spirits have extricated themselves from the swamp, they must make their way towards the mountains through the hard land and forests dominated by man. They must climb through dense underbrush and up the steep slopes, without special clothing and shoes. They must then climb the mountains that are dominated by Raven.

Raven is on a familiar basis with the dead since it lives off their remains. When Raven spots a spirit climbing toward the sky and the village of the dead, he knows that it is a soul whose body has not yet been cremated, so he pesters it, saying: "Why not leave your dead body for us to eat as other creatures do? Why do you allow it to be wasted by being consumed by fire? Of what benefit is that to us or to the creatures who live off us in turn?" If the soul is not respectful and skillfully deceitful in its answers, Ravens pecks at it until it loses its grip and falls back down into the valley. It must then begin its ascent all over again.

Needless to say, the more important the chief, the more envious are the creatures whose domain the chief must pass through on his way to the spirit world. So they delight in exacting a heavy price and making his journey more difficult.

Mask of Transformations

This mask tells about the most important transformations in the course of people's lives. Each of the sun's rays portrays a different transformation. The two middle rays show a woman in labor. They symbolize the reincarnation of a child from the world of spirits to the real world. The lower two rays show a woman being consumed by Raven. This symbolizes her death and return to the spirit world. The single upper ray symbolizes the unification of man and woman, and both of them being united with the animal world. This double unification is made possible through the medium of the shaman, whose head is shown

upside-down in a trance-like state—indicated by his hooded eyes and extended tongue. The unity of man and woman is indicated by their sharing the shaman's head. Their final reunification with the animal world is shown by the act of Raven consuming them both.

Death and Reincarnation

Figure 30 shows the frontal face of a mortuary box used to hold the remains of an important chief or shaman. The box is set atop a small totem pole. The head in the center of the box is that of a hawk swallowing its own beak. It represents death. The male and female children to either side of the head represent life, or in this case, reincarnation. The dragon-like creatures that encircle the hawk's head are in reality only one creature with two bodies and a common human head. This creature is Sisiutl. Indians who caught one while fishing were forbidden to kill it. It could bring either death or fortune, depending on how one handled it and the status of the handler. Sisiutl was also considered a source of great wisdom.

We know that this is a shaman's mortuary box, rather than a chief's, by the fact that the children's hair appears to be electrified and that the children are shown in x-ray vision form.

There is a strange play of imagery here. Although the children are portrayed as young and vigorous, they are illustrated by means of their bodies' hard elements only: heads, arms, legs and ribs. Their soft tissues, the ones that are consumed by Raven or fire after death, are not shown. This illustrates the tenuousness of life, for even though they are just being born through reincarnation, they are already marked by decay and death.

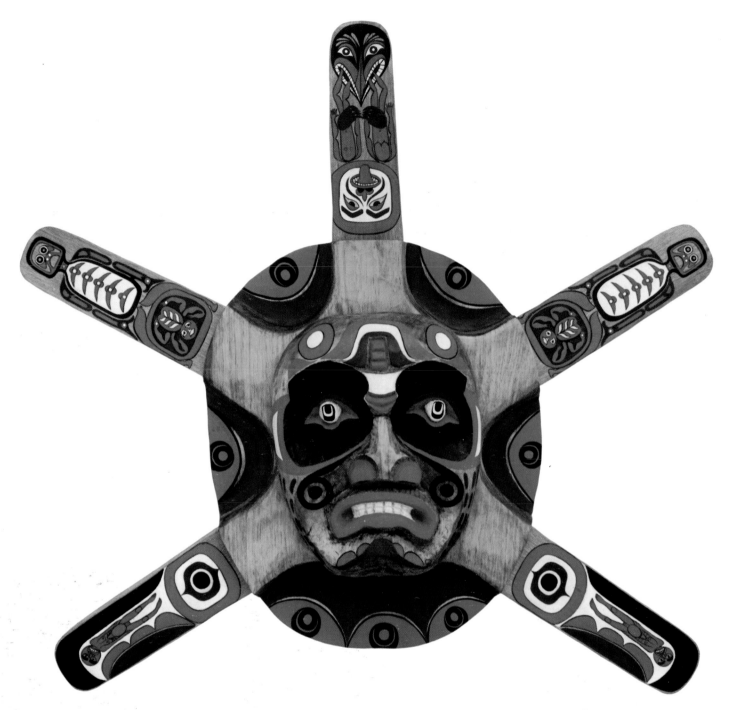

Fig. 29a

Figs. 29a, b, c, d: Mask of Transformations

This mask (Fig. 29a), inspired by one belonging to a Tlingit shaman, tells about the most important transformations in people's lives. The five sun rays together portray three different transformations.

The two middle rays (Fig. 29b) show a woman in labor. They symbolize the reincarnation of a child from the world of spirits to the real world.

The lower two rays (Fig. 29c) show a woman being consumed by Raven. This symbolizes her death and return to the spirit world.

The single upper ray (Fig. 29d) shows two transformations: man and woman becoming one through physical union; and both of them, in turn, being united with the animal world. This double unification is made possible through the medium of the shaman whose head is shown upside in a trance-like state—indicated by his hooded eyes and extended tongue. The unification of man and woman is indicated by their sharing of the shaman's head. Their final reunification with the animal world is indicated by Raven consuming them both.

Painted woods, 39 inches in diameter.

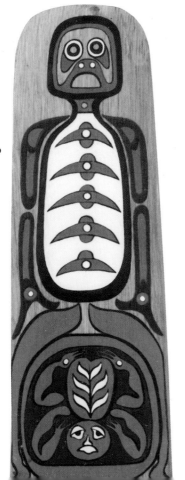

Fig. 29b

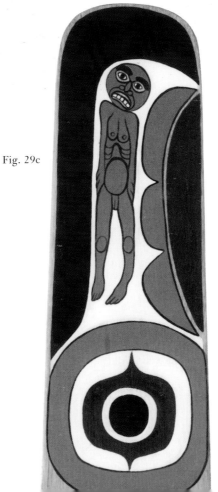

Fig. 29c

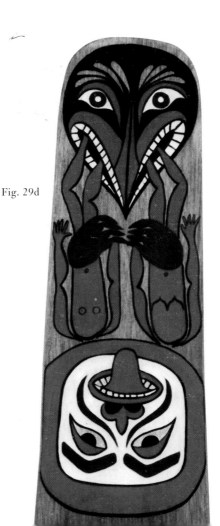

Fig. 29d

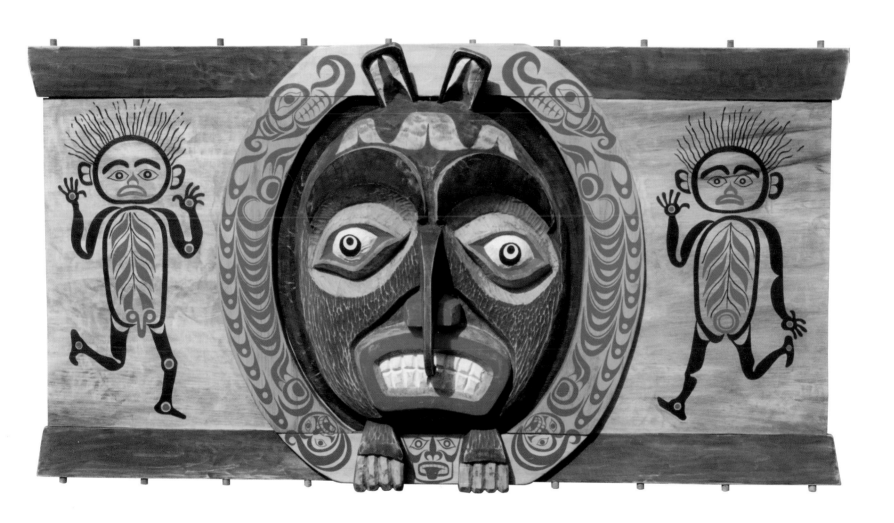

Fig. 30: Death and Reincarnation (Haida Shaman's Funerary Box Front)

This is the front face of a mortuary box used to hold the remains of an important chief or shaman. We know that this is a shaman's mortuary box, rather than a chief's, by the fact that the children's hair appears to be electrified and that they are shown in x-ray vision.

There are specific rules about how this box front can be constructed. Each piece of wood must be cut in a certain way and pegged together with other pieces in a proscribed fashion. The hawk's face, including ears, beak and feet, must be carved out of a single piece of wood.

Painted wood, 30 by 58 inches.

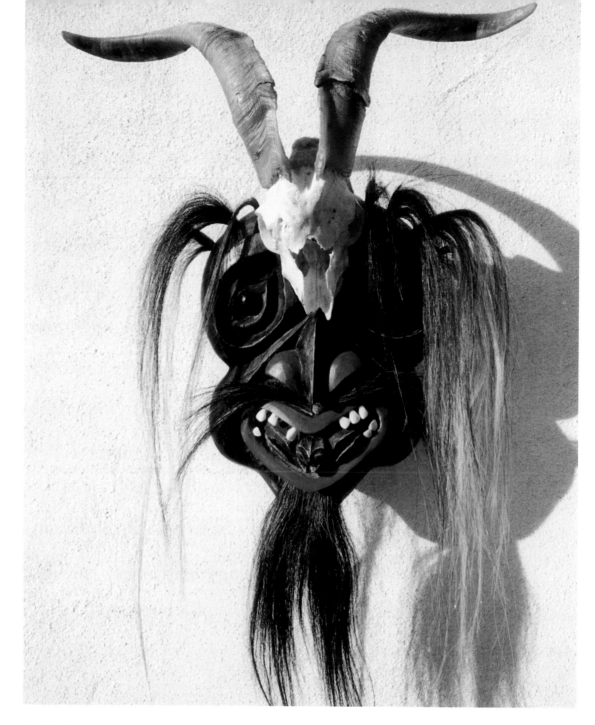

Fig. 31: Mask of the Mountain Goat Clan (How Mountain Goat Taught Man a Lesson)

The mask records the story of the origin of the Goat clan. It was inspired by those worn by Tlingit shamans (spiritual and medicine men) during their healing rituals. The wild and unkempt appearance of the hair and face is shows that the shaman is in a trance state and is intended to produce awe in the beholder. The hooded eyes and protruding tongue further indicate the trance. In addition to the powers of healing, shamans could harness the powers of nature to further their own objectives or those of the tribe. They could cause storms, activate animal spirits or let loose the powers of rivers and mountains.

Wood, mountain goat skull, antelope teeth, horse hair, 24 by 36 inches.

Mountain Goat Teaches Man a Lesson
(Origin of the Mountain Goat Clan)

The mountain goats of the Northwest normally range over the high, inaccessible mountains that border the Pacific coast. But in late winter, when they become lean from lack of food, they are forced down to the coastal lands to find vegetation. The coast is not covered by snow, and the grass there begins to sprout early. For the most part, the goats avoid the Indian villages and shun any contact with man. But when they are weak from hunger and need to eat to survive, they overcome their normal caution. In their weakened condition, they can be easily caught. And the young men of a particular Gitskan village frequently took advantage of the goats. They made a sport of maiming and even killing them—not for food, because there is not much worth eating in them that time of year—but for fun.

One day, a group of Indian youths captured a young goat and alternately pushed it into the fire and then into the cold river until it was burned and frozen and very near death. It was too weak even to bleat. The youngest son of the chief of the village, a prince, happened to be passing by and was appalled by what he saw. He rushed over and threw the young men to the ground to stop the torture. "We depend on these

animals for meat and wool," he told them. "You will make all of us pay a high price for the disrespect you show them."

The prince then lifted the injured goat into his arms and took it to his home to nurse back to health. He gave it warmth and nourishment and covered its burns with a crimson balm he had prepared from plant roots and whale blubber. In the spring he set the goat free to return to the other goats in their mountain pastures.

That summer, a group of mountain shepherds, clad in goat skin cloaks, came to the village to invite the young men to join them in a great feast they had prepared at their camp on the mountain. Although none of the young men knew the shepherds, they found them warm and friendly—and besides, no Indian could ever refuse an invitation to a feast. The young men invited the prince to join them. As they made their way up the mountain, the youngest of the shepherds took the prince aside, gave him a balm, and told him to paint his lips and nostrils crimson and to line his eyes with it so that he stood out from the other villagers.

Halfway up the mountain, the young shepherd picked up the skull of a goat who had been killed by the villagers earlier and asked the prince to tie it to his head with some strands of remaining skin. He then told the prince to stay close to him throughout the forthcoming feast.

After a long climb, they reached a large one-room house that was perched on the side of the mountain. The young villagers were offered the best seats: those on the side of the house that faced the coast and gave them a view of their village below. They gladly accepted. But the young shepherd pulled the prince aside and told him not to sit with the other young men of his tribe. Rather, he invited him to sit with the shepherds on the side of the room next to the mountainside.

The shepherds plied the young men of the village with food and drink and entertained them with songs and dances. After a while, the

young men grew sleepy and began to nod off. At that point, the shepherds rose as one and revealed themselves to be mountain goats. They rushed to the side of the house in which the villagers were dozing and jumped up and down until that side of the house began to creak and tremble. With a roar, it tore itself loose from the rest of the house and began to fall down the mountain. Being sure-footed, the goats jumped back to the side of the house that was still firm. The young goat quickly pulled the prince with him to safety. The side of the room with the young villagers cascaded down the side of the mountain, killing them all.

The young shepherd who had guided the prince through this ordeal now revealed himself to be the very goat the prince had saved from torture and near death that past winter. The kid then guided the prince down the mountain to his village, providing him with some of his own hair and portions of his hooves to attach to his feet so that he would be more sure-footed.

As they descended the mountain, they came to a large river that blocked the way. The young goat was able to jump over it easily, but the prince was unable to follow. The goat could not help him because goats are not natural swimmers. The goat was dismayed. He could not leave the young prince to starve to death as he had almost done last winter. He felt obliged to bring him home to his village safely, but there seemed no way out. The goat went over the dilemma in his mind, remembering all the kind things the prince had done for him. Suddenly the answer was there. It was so obvious, he could not understand why he had not seen it before. He told the prince: "It was your tongue that saved my life when you spoke harshly to the young men of your village who were torturing me. Now that very tongue of yours will come to your aid and save your life, too." "How?" asked the prince. "I can't talk the river into parting before me."

The goat laughed as the prince waited and wondered what he had in mind. And as he waited, his tongue began to swell until it gradually pushed its way out of his mouth. As it emerged, it grew larger still. The prince could now see that his own tongue was turning into a frog. His frog-tongue soon became as large as the rest of his head. At that point it jumped out of his mouth and into the river. The prince was speechless. In the river, the frog continued to grow until it was large enough to carry the prince across the river. From there, the young goat could easily lead the prince back to his village.

Following the tradition among Northwest Indians, the prince took the Mountain Goat for his clan name and crest. He then fashioned himself a mask that captured the key elements of the adventure he had just lived through. The human face of the mask (which represented the prince's face) had its eyelids and lips colored crimson. The face was crowned by Mountain Goat horns, and the prince's tongue, which protruded from his mouth, was in fact a frog.

MURALS AND SHAMANISTIC OBJECTS

Stories about lovers who descend into the underworld to retrieve their recently deceased loved ones appear in myths throughout the world. The heroes, of course, are different in each of these myths: sometimes they are male, sometimes female. And the obstacles the hero must overcome to bring his or her loved one back to the earth are usually different. They reflect the everyday life and values of each culture, and that is what makes them so fascinating—and revealing. In essence, however, these stories are the same: the lover refuses to accept the death of his love and, at great risk to himself, tries to reverse that death. Such stories usually end tragically, with the irretrievable loss not only of the loved one but of the lover as well.

If these stories have a moral it is that although undying love is commendable and can evoke many brave deeds, death's ruling is final and should not be challenged. Too much persistence, coupled with the unwillingness to accept death, can lead to other deaths. Man has the ability to end life, but not to restore it. Many will recognize in this Northwest Indian tale a similarity to the great Greek myth of Orpheus and Eurydice.

This tale probably initiates with the Tsimshian tribe because of their belief that the world of the dead lies deep in the sea.

Gunarh's Descent into the Underworld
(Shaman's Apron)

G unarh, the most skillful and crafty of the young hunters of his tribe, had won himself the beautiful daughter of the chief. Although of humble origin himself, Gunarh's outstanding skill and bravery made him acceptable to his bride's noble and wealthy family. Gunarh's tribe was organized as a matrilineal society, which meant that his children, through his wife's brothers, would inherit much of the chief's great wealth. Gunarh loved his new wife passionately. He did everything to please her, not just because she was beautiful and wealthy, but because she was also kind and loving. When she became pregnant, there was great joy throughout the tribe, but none greater than in Gunarh's heart. He now fished for salmon and hunted the otter and great whale obsessively. He wanted to acquire the great wealth and prestige he felt his wife deserved.

One day a large white sea otter was seen swimming along the shore in front of Gunarh's village. Sea otters are normally black, so this one drew a great deal of attention. The village hunters eyed it greedily. Catching it would be an honor that would live with the man who caught it all his life. The tale of the hunt might even become a tribal legend. But

the otter appeared to be oblivious of the hunters. It moved in close to shore and picked for its food from among the rocks and seaweed. The less experienced hunters paddled out to capture it, but they came at it too directly and it easily eluded them. This otter had two dorsal fins on its back so it maneuvered very quickly in the water.

For days Gunarh studied the otter's habits. He found that it liked to nap on the rocks and catch the last rays of the sun at the end of a heavy day of feeding. So, rather than approach the otter directly from land as the other hunters had done, he first rowed out to sea in another direction. And with the setting sun behind him to blind the otter, he brought his canoe up quietly behind it and with a quick blow, clubbed it over the head. With great pride, and with the entire tribe cheering, he presented the otter to his wife—the only white sea otter ever captured by any member of his tribe.

But what Gunarh had acquired in hunting skills and persistence, he lacked in overall knowledge. He should have realized that otters do not have even one dorsal fin, let alone two. And from the presence of two dorsal fins, he should have known that the otter was, in reality, Gilsadzant, the great spirit of K'wak, the white killer whale god of the sea underworld. In Gunarh's culture, this underworld is where people go when they die.

As Gunarh's wife was preparing to skin the otter at the water's edge, the otter slowly began drifting out to sea with her—so slowly, she did not even notice she was moving. The children of the tribe rushed to Gunarh and pointed out his wife and the white otter as they drifted off toward the horizon.

Gunarh quickly called his comrades together. They launched two dugout boats and paddled after Gunarh's wife and the otter who was kidnapping her. As they approached, the otter pulled Gunarh's wife

toward the spouting hole that led to K'wak's undersea world. This was a large whirlpool that all fishermen avoided. In an instant Gilsadzant entered the whirlpool and pulled Gunarh's wife down with him into his underworld—the world of the dead.

But Gunarh was clever enough to be cautious, and he avoided becoming trapped in the whirlpool. He realized that if he allowed himself to be pulled down, he would disappear forever. So he threw his heavy anchor into the water and asked that his comrades do the same with their anchors. He then lashed the two dugouts together, tied a rope to himself, and jumped down into K'wak's breathing hole, reasoning that once he had rescued his wife, he could use that rope to pull them both back up and out of the underworld.

When Gunarh swam down to the bottom of the whirlpool, he did not see the white otter. Instead, he saw a great white killer whale sitting on a throne. This was Gilsadzant in his normal form, and sitting beside him like a beautiful queen was Gunarh's wife. She seemed blissfully unaware of her recent kidnapping and was no longer able to recognize Gunarh. The evil Gilsadzant had clouded his wife's mind. She had already entered the world of the dead. Gunarh approached them carefully, for he could see that Gilsadzant's fins could reach out over ten feet. As Gunarh came close, Gilsadzant laughed and leaned forward. With one easy slap of his fin, he swatted Gunarh so far away that he could barely make out his wife sitting beside Gilsadzant.

Gunarh came to rest on the sea floor beside the giant clam, Hahloon. Although Hahloon had lost his sight, he was able to sense everything that was going on in the undersea world of the spirits. He took pity on Gunarh and warned him: "This is all part of a scheming plan by Gilsadzant. He means not only to make your beautiful wife his queen, he wants to destroy you." Gunarh was taken completely by surprise.

Everything began to make sense now. Hahloon explained: "Don't you see? You are such a good hunter, you are robbing him of his finest otters, whales and porpoises."

Gunarh now began to wonder why Hahloon was being so helpful. "Be careful!" Hahloon continued, "Gilsadzant knows everything and is very deceitful. He knows that you have a reputation for persistence, and he means to use that very trait against you. He will let you keep trying to get your wife, allowing you to get closer and closer, then he will catch you up in his giant teeth and eat you. He has done that before. In fact, he is the one who robbed me of my sight many years ago. He thought I was growing too big and would become a threat to his dominion over the underwater spirit world."

Now Gunarh understood and became angry. For not only had Gilsadzant stolen his wife, he had insulted him. For the Northwest Indians, an insult is the worst form of injury and must be avenged immediately. "Tell me how I can be victorious over this giant," said Gunarh, his face grim and flush with anger.

"Do not be impatient, for you will only be able to win with my assistance," replied Hahloon. "But for me to be able to help you, you must first restore my sight. As I told you, Gilsadzant stole my eyes."

"Where are they?" asked Gunarh. The giant clam pointed to two large oysters that lay sleeping nearby. Gunarh understood immediately. He swam over to the oysters and knocked on their shells. When they awoke and menaced him, he quickly said: "I know that each of you has within him an irritating piece of sand that has, over the years, grown to become a large pearl. If you open your shells, I will swim inside and dig out the pearls from your flesh and relieve you of your irritation."

"Why do you want our pearls?" asked both oysters suspiciously—speaking in unison.

"I will use them to restore Hahloon's sight," replied Gunarh. "He will then be able to help me defeat Gilsadzant and free the underworld from his domination."

"And how will that help us?" asked the oysters.

Gunarh replied without hesitation, even if he was taking liberties with the truth: "Hahloon will become the new ruler of this undersea world and will be your benevolent protector, unlike Gilsadzant, who is now your evil taskmaster."

The oysters consulted each other and slowly agreed. The first one opened its shell to allow Gunarh to swim inside it. Gunarh swam carefully because he knew he was in a very precarious position. He located the pearl. It was embedded deep in the oyster's flesh. With much effort, he managed to pull it free. The oyster thanked him for his effort. The second oyster then opened its shell to allow Gunarh to swim in. But this time Gunarh had trouble locating the pearl. When he finally found it, he realized that it was so deeply embedded, he would never be able to pull it free by hand. He pulled tight on the rope that connected him to his canoe so that it became a tension cord. He grabbed the oyster's flesh with his knees so that he would not be pulled out by his own rope, and with one quick cut of his knife, he opened the oyster's flesh and pulled the pearl free. The oyster reacted to the pain by beginning to shut his shell. He would have swallowed Gunarh alive. But Gunarh let go of the oyster's flesh, and his tensioned rope yanked him free. The giant oyster shell snapped shut a hairsbreadth from Gunarh's feet.

The second oyster complained to Gunarh: "Why did you cut me with your knife?"

"I couldn't get it out any other way," Gunarh explained.

Gunarh held up both pearls, and they began to glow in his hands. "These are the pearls that were his eyes," he said of Hahloon. He

swam over and affixed the pearls to Hahloon's flesh. The pearls opened up as eyes. They gleamed for being able to see again.

"Look," said Hahloon pointing to Gilsadzant, both pleased and proud that he could see again. "If you study him carefully, you will see that because he is very large, he is also very awkward. He cannot turn quickly. It will be easy for you to trip him up if you go about it the right way. Also, look at his left cheek. It is so heavy, it blocks the sight out of his left eye. That is the price he pays for being so obese. So here is what you must do. Approach Gilsadzant from his left side. Then call to him. When he turns around to see you out of his right eye, he will be off balance. If you are quick, you can trip him up and steal your wife back. But then you must rush away with her quickly, because Gilsadzant will surely come after you, and he can be very fast once he starts moving."

Gunarh turned to swim toward his wife, but Hahloon called after him: "Remember, your wife must climb the rope behind you quickly too. You don't have the luxury of looking back. Remember! Fear death by drowning, and under no circumstances are you to look back!" Drowning was the form of death most feared by the Northwest Indians because the body could not be recovered and cremated, and the spirits could not be freed to dwell in the spirit world and be reincarnated.

Gunarh followed Hahloon's advice to the letter. He got Gilsadzant off balance and freed his wife from his fin. When he touched her, she snapped out of her daze and recognized him immediately. He pulled her over to the rope and told her to climb it behind him—and to be quick about it. For already he could see Gilsadzant regaining his balance. "You must do it right the first time," he warned, "because I will not be able to look back and help you." "Don't worry about me," she reassured him.

They had almost reached the air hole, when Gunarh felt a rush of water turbulence. He knew that Gilsadzant was right there behind him. He reached back to his wife to pull her out of the whirlpool, but as he touched her, she froze and was no longer able to move. Gilsadzant came up behind her and swallowed her in one gulp. Gunarh was devastated. He was so angry with himself for forgetting Hahloon's warning, he let go of his rope and flung himself violently at Gilsadzant. And this is exactly what Gilsadzant wanted, for he swallowed him up too.

Such is the way of love that is too strong, and daring, which knows no limits. Although Gunarh and his wife were no longer among the living, they were reunited in the world of the spirits as illustrated in the shaman's deer skin apron (Figure 32).

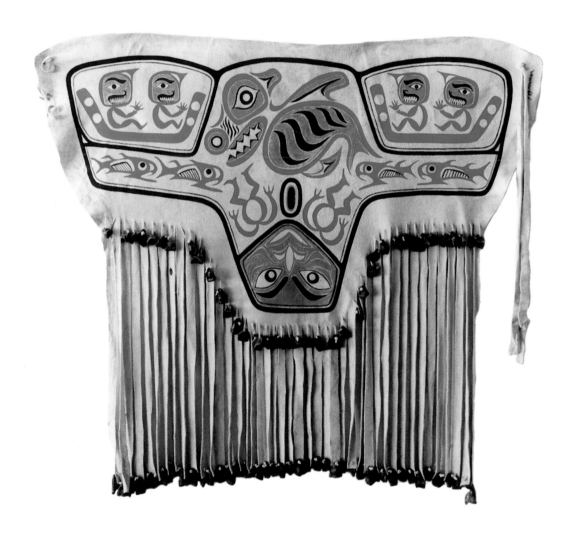

Secret Stories in the Art of the Northwest Indian

Fig. 32: Gunarh's Descent into the Underworld

The legend illustrated on this shaman's apron is of a lover, Gunarh, who refuses to accept the finality of the death of his love and, at great risk to himself, strives to reverse it. The story ends tragically, with the irretrievable loss not only of the loved one but of the Gunarh himself.

At the top center of the apron is a Killer Whale with two dorsal fins. This is Gilsadzant, ruler of the undersea world of the dead who has stolen Gunarh's wife and brought her to his realm to be his queen. The dugout canoes are filled with Gunarh's friends who have come to help him retrieve his lost love. The upside down head at the bottom of the apron is that of a shaman, in trance. The two bodies who share that head are the two lovers, Gunarh and his wife, who have been reunited in the world of the spirits.

The apron is made of deer skin. Deer hooves are tied to the top and bottom fringes so that they rattle against each other when the shaman dances. The apron is used by the shaman at the funeral of someone who has drowned to comfort his living partner. Drowning is the most feared form of death because, if the body is not recovered, it cannot be reincarnated. The purpose of this shaman's story telling and dance is to dissuade the grieving partner from attempting to risk his own life to retrieve his partner's body.

Paint on deer skin, with deer hooves. 33 inches wide by 29 inches high.

Thunderbird and Killer Whale Murals
(A Coming-of-Age Story)

Both of the murals shown and discussed below are illustrations of the same Thunderbird and Killer Whale myth that I presented earlier as the basis for my totem pole.

The two murals I painted were each inspired by murals that once existed in different locations on the Northwest coast. I will first present a brief synopsis of the myth and then discuss how each mural interprets it and identify where the original was located.

The Myth

A young Indian prince wanted to marry the daughter of the wealthy chief who led the annual whale hunt. But her father wanted him to prove he was a brave hunter. The prince was of shaman descent and knew the magic ways. He had with him a snake and wolf that were the Lightning and Thunder of Thunderbird. Thunderbird is the physical embodiment of a thundercloud that passes overhead and brings the storm. When the chief asked the young prince to join the whale hunt, he readily accepted, but insisted on bringing along his wolf and snake.

A killer whale had followed the whales on their migration north and was attacking the newborn calves. When the chief fell overboard, the killer whale rushed to the surface and swallowed him. The prince turned himself into Thunderbird and sent his snake and wolf into the water to attack Killer Whale. While the killer whale was preoccupied with fighting them off, the prince sunk his claws into Killer Whale, lifted him out of the water and flew him back to camp. Killer Whale was cut open and the chief released. The chief had no choice but to accept the prince as his new son-in-law.

Version 1

The original of this mural was located on the wall of the trading post at Chitchat Harbor. It appears in a photograph taken in 1892. Thunderbird is shown in the center with his claws dug into Killer Whale. He is about to pull Killer Whale out of the water. The prince's snake (left) and his wolf (right) are shown harassing Killer Whale. The various symbols incorporated in the design of Thunderbird speak to his lifelong achievements and trading and fishing rights (Fig. 33).

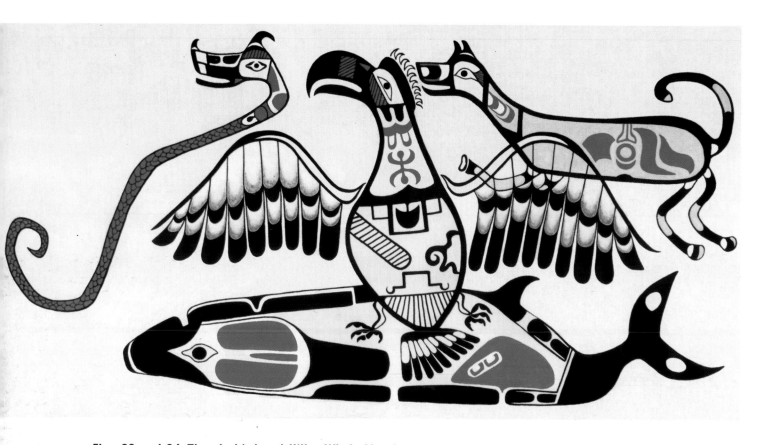

Figs. 33 and 34: Thunderbird and Killer Whale Murals

A young Indian prince wanted to marry the daughter of the wealthy chief who led the annual whale hunt. But her father wanted him to prove he was a brave hunter. The prince was of shaman descent and knew the magic ways. He had with him a snake and wolf that were the Lightning and Thunder of Thunderbird. Thunderbird is the physical embodiment of a thundercloud that passes overhead and brings the storm. When the chief asked the young prince to join the whale hunt, he readily accepted, but insisted on bringing along his wolf and snake.

Killer Whale was accompanying the whales on their migration north and was attacking the newborn calves. When the chief fell overboard, Killer Whale rushed to the surface and swallowed him. The prince turned himself into Thunderbird and sent his snake and wolf into the water to attack Killer Whale. While Killer Whale was preoccupied with fighting them off, the prince sunk his claws into him, lifted him out of the water and flew them back to camp where Killer Whale was cut open and the chief released. Of course the chief accepted the prince as his new son-in-law.

Fig. 33: Thunderbird is shown in the center with his claws dug into Killer Whale. The prince's snake (left) is shown both as a snake and as the jagged lightning he represents. His wolf (right) is shown harassing Killer Whale. Some of the creatures in this mural are shown in x-ray vision, exposing their skeletons and organs. There are various symbols incorporated within the body of Thunderbird that speak to his lifelong achievements.
Paint on exterior stucco, 8 feet by 12 feet. Located in the Catskill Mountains.

Version 2

The original of this mural was painted on a chief's house located in Pishicaw, at the mouth of the Skeena River. It is not as elaborate or detailed in its storytelling as the previous one, but it does capture the main story (Fig. 34).

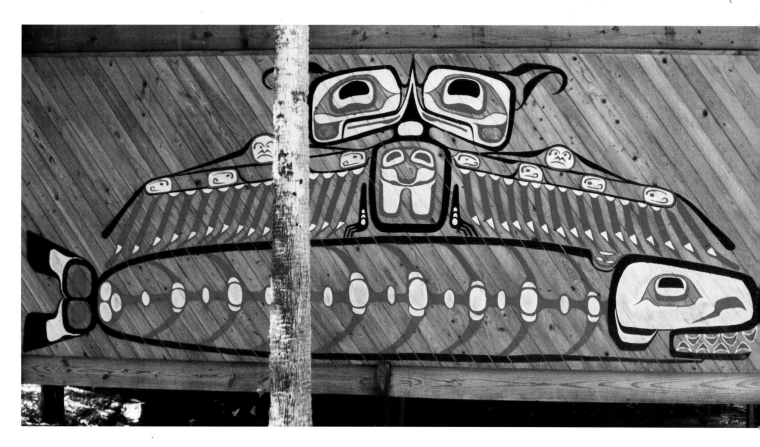

Fig. 34: The only two players in this mural are Thunderbird and Killer Whale. Both are shown in skeletal relief. Thunderbird has the heads of chiefs for wing joints. For some reason, Thunderbird is here shown as pregnant, even though the Myth represents him as being male. Perhaps it anticipates the productive union of the young couple and also anticipates husbands who now customarily say of their wife and themselves: "We're pregnant."
Paint on wood,12 feet by 20 feet. Located in Florida.

Eagle, Whale, Sex and Succession
(Chilkat Blanket)

The chief of a great village on the Skeena River was becoming old and looked to the eldest son of his oldest sister to succeed him. When the boy reached puberty, he left his mother's house and moved in with his uncle, the chief. This was customary among the Northwest Indians. The chief had many houses and allowed the young man to live in one of them, but not the one occupied by the chief's immediate family. When the young man turned twenty, the chief invited him to live in his main house and began to groom him as his heir. The young man attended all the important meetings and ceremonies with the chief and sat beside him through all of them. Whether in earnest or for show, the chief often leaned over to the young man and appeared to consult him before making a decision.

Such seating arrangements and gestures were of great importance to the Northwest Indian, and the tribe assumed that the chief had chosen his successor. The young man was given free reign in the chief's house. So great was the new respect shown him, he was allowed to go anywhere and speak with anyone he wanted to.

It did not take long for the young heir to come upon the chief's youngest and prettiest wife. Their eyes caught in surprise and held. They had not been introduced to each other. She was younger than he was. She smiled at the astonished look on his face. He finally smiled back, at which she turned and ran away, but not without a quick glance over her shoulder. He read that as an invitation. It did not take him long to learn that because the chief had many wives and was advancing in years, she slept alone most nights.

One night he came to her bed and was well received. They soon became ardent lovers, seeking out each other's company whenever they could and whenever the chief was otherwise occupied. The young man had boundless energy, and she taught him things about making love she had learned from the chief. Their liaisons soon became public knowledge, although no one dared to say anything to them. The couple made the mistake of thinking that this lack of comment implied approval.

One day the chief came upon them making love in her bed during the day. He withdrew without being noticed and spent the next two days alone in contemplation. When he reappeared, he summoned

two of his other nephews and asked them to prepare a long, heavy plank and to cover it with fresh cedar resin.

That night, the chief waited for his beautiful young wife to fall asleep, came into her room, quietly laid the plank down on the bed beside her and withdrew. When her young lover lay down beside her, he got stuck. He tried to disengage himself from the pitch, but the more he struggled, the worse it got. His young mistress awoke to find him shaking in the strangest manner. She thought he was possessed by a spirit and began to scream. The young man tried to quiet her down, but it was too late. The chief came into her room with his two other nephews and ordered them to lift up his heir, plank and all, and carry him out to the beach. The chief did not even acknowledge the protestations of his young wife.

The nephews carried the young man to an old canoe and set him down inside it, wedging the plank tightly against the sides. When he was fixed in place, the chief approached and spoke to him for the first time in days: "It is not so much what you did that disappoints me, as how you did it. I have known for a long time that you have been sleeping with my prettiest young wife. I even suspected that would happen when I first asked you to come and live with me in my most private of houses. And you were a fool not to know that I might even welcome your overtures to my young wife, because how can an old man satisfy the sexual needs of his youngest and most active mistress? Your biggest offense to me was to go about your activity so brazenly that everyone in my family, even my most lowly slave, knew about it. You have not only revealed me to be unable to satisfy my women, you have shown everyone that I had poor judgment in selecting you as my heir and in inviting you to share my household. Finally, you have suggested that I was too weak to stop this

outrage. Now, with this action, I will show my family that they are wrong about me in all respects."

And with that, the chief signaled his two other nephews to push the canoe out to sea. It quickly got caught in the outgoing tide. The young man felt himself moving into choppy waters. If the canoe flipped over, he would certainly drown.

He tried to lift himself up to see where the canoe was taking him, but the plank was wedged into the canoe too tightly. He tried to pull himself free, but only succeeded in tearing his skin. The pitch had hardened in the cold night air. He waited for the night to end.

He awoke from a deep sleep to feel the warm rays of the sun beating down on him. He could smell the cedar resin now and realized it was softening. He yanked up his head and tore his hair free of the plank. He looked around but could not see land anywhere. He had drifted far out to sea.

By midday, the pitch had loosened enough to allow him to raise his upper body. He could see himself drifting towards a small island. He paddled furiously with his hands, realizing that if he did not make land before nightfall and pull himself free, the pitch would again harden and he would die of thirst.

As soon as the canoe touched the beach, he turned it over on himself and pulled himself down from the pitch and plank. He crawled out from under the canoe and pulled himself onto the beach. He covered himself with leaves and slept through the night. When he awoke, he found that the canoe had drifted away. He walked around the island and saw that it was desolate. Except for a few berries and a spring, there was nothing to eat. It was likely he would soon starve to death.

He wondered at how quickly he had gone from being heir to a fortune and leader of his people to being a starving fool. He was fearful

that if he died without a proper burial, his spirit would not be reincarnated. His eternal being would end with himself. He was as lowly as a slave. He laid himself down and cried in self pity.

As he wept, he felt something pinching his leg. He moved away from it but it followed him. He looked down to see a mouse squeaking at him. He thought: At least it's a meal, and tried to grab it. But it scampered away and squeaked at him: "Give me your wool and fat!"

"Wool and fat? You must be mad. Where am I going to find wool and fat?"

"You have it," insisted the mouse.

The young man thought a bit and realized the mouse was right. Every Northwest Indian who went out to sea carried under his belt a small quantity of fat to spread over his face and wool to stuff in his ears against the wind. He gave these to the mouse. Of what use were they to him now?

The mouse scurried off with them, and the young man realized he must have been hallucinating to think he had been talking to a mouse. He was obviously in a bad state. But in a short while, the mouse returned with two dozen other mice. And each carried a great quantity of wool and fat and a woven cloak for him to wear. The mouse said: "Your generosity to me when you yourself had nothing shows that you have the makings of a great leader. My king will welcome you, for he has been looking for a suitor for his daughter and has turned all away. Follow us to his great house, and we will give him all this wool and fat as your gift to him."

The young man realized that he must have landed on the famous Island of the Spirits. He thought it wise to do as he was told, even by a mouse. He entered a cave and followed the mice down a steep trail and through a narrow hole that opened into a huge cavern. It was filled

with people who spoke a language he could not follow. It seemed familiar, but even when he listened hard, he could not understand it.

The mice led him to a large platform at the rear of the cavern. On it sat the great king with his wife and daughter. They were all big people—half again as large as he was. No wonder they could not find his daughter a suitor. The mouse addressed the king: "This brave and handsome young man brings you these generous gifts." He set the wool and fat before the king. As the gifts touched the ground before the king, they turned into precious blankets, animal skins and whale blubber. The king's eyes widened. The queen said: "Have the young man sit by us, here by our daughter." And she urged her daughter to select the tastiest morsels to feed him. It was obvious that the queen, at least, had selected the young man as her daughter's suitor.

Shortly after the meal, the king gave a signal and everyone retired for the night. The daughter took the young man's hand and led him to her room. She hugged him and led him to her bed. She was so large, he felt crushed in her arms. He knew that he would never be able to satisfy her as a lover should. He asked if she would excuse him for a moment and show him the way back to the beach. She thought he wished to clean himself and to attend to his bodily functions.

He searched the beach for a large polished stone and at last found one shaped like an erect, human penis, but twice as large. He hid it under his cloak and returned to her bedroom. That night he used the stone as he had been taught by his uncle's beautiful young wife. It was a trick she herself had learned from her husband, because the old chief was well beyond the age of being able to satisfy his young wife with his own member.

The next morning, the king and queen could see from the contentment on their daughter's face and the way she clung to the young

man, that he had satisfied her longings. "Prepare a feast," said the king, "because we shall have a great wedding. Meanwhile, bring me one of my great eagle cloaks so that I can give it to this young man, for he should know that he has joined the clan of eagles. Let us see if he is truly worthy of us before the wedding."

As everyone watched, two braves helped the young man put on the eagle costume with its two large wings. The king then shouted: "Now you must fly out to sea and bring us back a great fish for our wedding feast."

The young man could barely walk in the costume, let alone fly. His future wife led him out to the beach as he dragged his wings and his fallen spirits behind him.

"I will never be able to get off the ground with these things. What can I do?" he asked her. "If I come back empty-handed, I will disappoint the king and lose you as my wife."

"No one can fly with those wings right away. You must find a cliff and practice. It is many weeks to the wedding, and you will have plenty time to learn."

Slowly, the young man got the knack of the cumbersome wings and learned to fly. One day, he flew out to sea and practiced catching fish with his talons. It was no easy task spearing a fish from the air. More often than not, the fish pulled him into the water. He finally contented himself with taking a salmon and bringing it ashore. It was his first catch. He presented it to the king with great pride. The king showed it around to everyone and they laughed heartily. "We can't all eat from this," he said. "It will barely serve me. Bring us a fish that will feed us all at the wedding!"

When the young man told his fiancée, she warned him: "Be careful when my father challenges you. He is trying to show you up as

weak, and he means to destroy you before you can succeed him. He has done this to every one of my former suitors, but I have learned, and now I will help you." She opened a finely carved and painted wooden box, took out another eagle garment and pulled it on herself. "Come, I will teach you how to fish."

They flew out to sea together, she led and he followed. At first, the young man had trouble keeping up with her, but as he flew, he could feel his strength increasing. Gradually, he overtook her, but then, he realized that he was getting his new strength from her. He flew beside her proudly.

In the distance, they saw a cloud of seagulls and the king's daughter flew towards it. Whales were feeding in the ocean. "Now you will bring the king a dish with which to serve the entire tribe," she said. "Pick yourself a young whale and bring him in."

The young man looked at her in astonishment, but did as he was told. He sank his talons into a young whale and tried to lift it out of the water. It dove, and he was pulled into the sea. He flapped his wings frantically, but they were penetrating the water and were losing their effectiveness. He called to his fiancée who was flying overhead: "If I hold on, he will drown me."

The king's daughter flew down to him and grasped the whale with her talons too. Now, the young man felt her strength enter his body. His wings beat furiously. Together they raised the young whale out of the water and flew it home. As they approached the camp, the king's daughter let go of the whale so that the young man could bring it in by himself. He circled the camp a few times until everyone gathered outside to watch and shout up to him: "You are Eagle! You are Eagle!" When he landed, the king greeted him and said: "You are the greatest hunter our village has seen since I was a young man. You have made our clan proud

to be Eagles. Prepare a feast!" he called to his servants. "We will have the wedding now."

When they ate the whale, it would not diminish in size and everyone at the feast ate to his heart's content. The young man realized that this too was because of his new wife's magic powers. For she had not only inherited her father's magic, but that of her mother, the daughter of a powerful shaman. His wife announced that the very next day she would begin weaving him a cloak that would not only portray eagles, but whales. "From this day forward, we will call ourselves Whales as well as Eagles and adopt their image as our crest." None of those assembled challenged her. How could they? For no one had ever achieved such a feat. The king then said that it was clear that everyone accepted the young man as his heir. In a short time, he had expanded the tribe's powers and made them all wealthy, for they could now hunt whale as never before.

The next day, the young man walked around the camp with a lowered head and mournful eyes. He barely smiled when people congratulated him on his extraordinary achievement. The king was informed of the young man's malaise and asked his daughter to put aside her weaving and find out what was wrong. The young man explained: "Now that I am accepted here, I think of my own village where I was to become the great chief. I left a world behind when I fell asleep in the canoe and it pulled me out to sea. Now, with my new power and position here, I want to return home and claim the succession that is rightfully mine." But he did not dare tell them of the ignoble acts that had led to his expulsion from the village.

The king was dismayed to hear of the young man's sadness. He called together an assembly of elders, his wife and daughter, and spoke to the young man. "All those things that happened in your former

village, I made happen. It was no accident that your chief's young wife fell in love with you; no accident that the king found you out; and it was I who made him so angry that he behaved irrationally and shipped you out to sea. It was I who made the ocean currents bring you here. All to the purpose that has just come to pass. Your old tribe believes that you are dead, and they have chosen someone else to replace the old king, who is still alive, but dying. Your place is here among us. Your old village is too far away for you to rule in both places at the same time."

The young man was perturbed that his new father-in-law knew so much about his past, and even more troubled to learn that others had determined his fate. It severely diminished his own achievements and self-image. He became more resolved than ever to return to his former village.

When his daughter told him that her husband meant to depart the next day, the king was greatly disappointed. "You must not let him go alone," he told her. "It is a far greater journey than he realizes. And if you wish to see him again, you must accompany him and never let him out of your sight. Forces are conspiring against him. Hurry and finish his cloak, for it will show his new crests and power and everyone will be frightened of him. Before you depart, I will give you gifts to take with you on your journey."

When the couple went to the king to bid him farewell, he gave them a bag of pebbles, a small carving of an eagle pole and a large package of wool and fat. "Of what purpose are these?" asked the young man, concerned that they were taking along unnecessary baggage on a long trip.

"Yours is a journey of many days," said the king. "When you tire in your flying, drop one of these pebbles into the sea, it will lighten

your load. When you arrive at your destination, present this package of wool and fat to your uncle, the chief. It will assure you a warm reception."

The young man thanked the king, and they flew off amid shouts from the people, begging them to return quickly. After they were flying a while, the young man said to his wife: "Let us discard this bag of pebbles and parcel of wool and fat, neither will accomplish anything. Dropping a pebble each time we get tired may lighten our load a bit, but meanwhile we are carrying all of them, and they weigh a lot together. And my people are very wealthy, what is a parcel of wool and fat to them?" But his wife said: "If they are too heavy for you, let me carry them."

They flew all day and began to tire, but the ocean was still empty of land. The king's daughter took a pebble out of the bag and dropped it into the water. A lush island materialized from it, and they flew down to feed themselves and rest. And this happened every day of their journey until the bag of pebbles was exhausted.

When they arrived at the young man's old village, his bride could see why her husband wanted to return: it had over twenty long houses and scores of totem poles. The banks of the river were covered with long canoes, and the beach was filled with fish-drying racks, although they were strangely empty of fish. Everyone walked around dressed in warm, decorated blankets, and they wore silver rings in their ears and noses. "No wonder you were reluctant to present your uncle with this parcel of wool and fat," she said.

When his clan recognized the young man, they became frightened. They thought he had returned from the dead. They ran ahead to warn the chief. When the young man and his bride approached the chief's house, they found the area around it deserted. The young man told his bride to set down the parcel of wool and fat at the frontal pole opening. They stepped inside and saw the chief sitting on his raised

platform surrounded by the heads of the tribe's noble families, all relatives of the chief. When they came near, the nobles withdrew behind the chief. The chief, who had aged considerably, tried to show no fear, but he trembled as he spoke.

"Have you come to wreak vengeance on me for sending you away, my nephew? My act was justified, as I explained to you. Have pity on me, I am an old man, and I assure you that my elder sister, your mother, has already punished me enough for my poor treatment of you."

"You meant for me to die, that is more than poor treatment. But I hold no grudge. I came to claim my rightful inheritance and to have my mother meet my new bride."

"Is this giant that stands beside you your new bride? From what tribe does she come? We know of no giants who are not also demons."

The young man had become so accustomed to living among the tall people of Spirit Island that he no longer thought of them as being unusually large. "I assure you that she is neither giant nor demon."

"How do you know that? How do you know that you did not die and are not, in fact, a spirit yourself?"

This startled the young man. He remembered thinking the island strange and possibly inhabited by spirits the first time the mouse spoke to him, but he never thought about it after that. Now, he remembered the incident with the wool and fat, and how odd he had found that, but he had accepted it, because it served his purpose.

"Let me prove to you that I am not a spirit: I left a small parcel of gifts outside the door for you. Send your servants to fetch it, you will soon know whether we are spirits or not."

With a wave of his hand, the chief dispatched a servant to retrieve the parcel. He soon reappeared: "There is a mountain of

glorious gifts waiting out there for you: otter skins and coats, whale oil, wool cloaks and blankets. And there is a small totem pole crowned with an eagle. It will take ten men to carry all these things in to you."

The chief motioned to some young men, and they leapt forward to bring in the wondrous gifts. The chief got up from his stool and selected the most prized of the otter skin coats. He put it on, and it made him look most imposing. He could see renewed respect in the eyes of his people. "I am now assured that the two of you are real people. Go fetch my eldest sister!" he ordered.

But the young man was far from reassured. Had the servants brought in a small parcel of wool and fat, he would have been more comfortable, but these had turned into real treasure. Now he wondered whether those past years on the island were real. He looked at his bride, and she beamed back at him. She was indeed a giant, no wonder she had scared off the villagers.

"You seem to be prospering," the young man told the chief. "Everyone is well dressed."

"The clothes are leftovers from more prosperous times. The fishing has been poor lately, and we go to sleep hungry."

"Your days of hunger are over. My wife and I are wonderful fishermen. We will soon bring you more fish than all of you can eat." With that the couple left the chief's house, put on their eagle costumes, rose into the air and headed out to sea. Repeatedly, they returned with more and more fish and sea mammals, until the beach was piled high with bounty.

The chief ordered a potlatch to celebrate this good fortune, and sent messengers to bring in the chiefs from neighboring tribes. This potlatch would celebrate the anointing of a new chief: his long lost nephew who had returned to him remade.

The young man's bride was very pleased with her husband's good fortune. She put aside any reservations she or her father might have had about returning to this place.

But just as she was pleased, another woman was saddened. This was the beautiful young wife of the chief—the one over whom all this trouble had started. She wished to renew her love for the young man, particularly now that he was assured of becoming chief. She was more beautiful than the young man's giant wife, and more gracious and skilled in the ways of luring men.

Every morning when the young man's wife fetched water from the well, she dipped the tip of the eagle feather she wore in her hair into it. When the young man asked why she did that, she replied that it revealed if the well water was poisoned. One day, as the young man looked on, his wife dipped in the feather, and the water turned slimy and dirty.

"Why is it doing that?" he asked.

"Because you have deceived me with your uncle's young wife. You only pretend to love me, but you associate freely with other women. I am now returning to my country, where all are faithful to one another."

"Forgive me, I have made a mistake. I should have said no, but it was hard to resist her. It won't happen again, I assure you."

"People don't change," she replied. And with that she put on her eagle garments and flew off.

The young man put on his eagle costume too and followed. "Come back, come back, I made a mistake," he shouted. "Please forgive me!"

They flew all day, and he fell further and further behind. His strength was giving out. He had no magic stones with which to create islands.

"Come back!" he shouted, "I can't go on."

"Return to your other woman," his wife shouted back, "that is what you thrive on, love built on deception." She looked back and saw her husband slowly falling into the sea. She flew back, but by the time she got to him he had disappeared under the water.

She flew on to Spirit Island and told her father, the king, what had happened. He was also deeply saddened, even though he had foreseen the entire course of events.

His daughter retired to her bed and refused all food and visitors. After a few days, it became clear that she was dying, and her father came to see her. "If you want me to bring your husband back, I will." His daughter nodded yes.

The king went to the rear of his house and lifted a trap door. Looking down, he could see to the bottom of the ocean. (The Northwest Indian believed that the oceans extended beneath the land.) He took a long dip net and fished around the sea bottom, until he found what he wanted. He brought the net up with the drowned body of the young man. He laid the body out on the floor beside his daughter's bed and covered it with a blanket. He jumped over it three times and then retired to his room.

The next morning, the king returned and lifted the blanket. The young man lay there as if sound asleep. The king said to his daughter: "He is back with us. He would not have returned if he did not very much want to be with you. Only you can wake him from his sleep."

She took her husband's hand in hers and gently called his name. He awoke, saw where he was, and embraced his wife.

"You have been far away, but at long last have returned to me."

"I have come to fetch you home," he said. "My uncle has died, and my people wish me to be their chief and for us both to live

with them. I will send my uncle's young wife away to live with her own family."

"It is not her problem, but yours," she replied.

"I will change," he promised. His wife nodded.

They flew back to his tribe to the rejoicing of his people. They produced many children and lived together a long time.

(This is one of the truly great myths of the Northwest. It belongs to the Gitrhawn Eagles Clan and is also shared by the Haida and the Tsimshian tribes.)

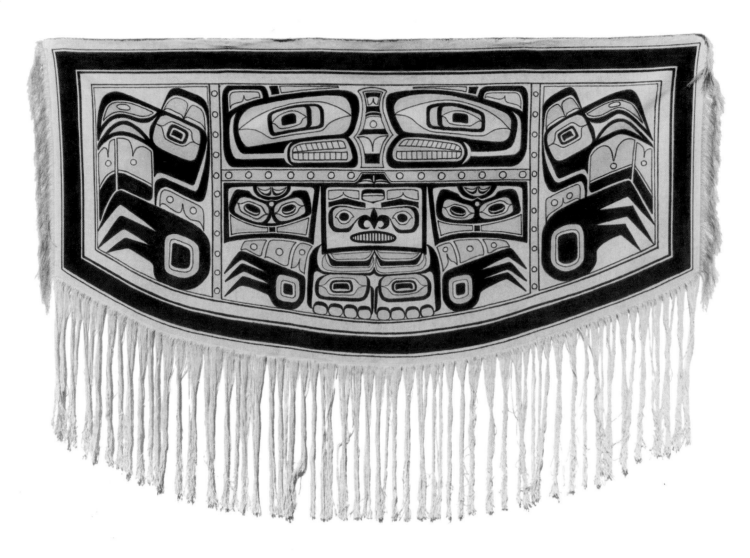

Fig. 35: Eagle, Whale, Sex and Succession (Chilkat Blanket)

Although there is repetitive form in the design of every Chilkat blanket, each is distinctive in its own way and tells its own story. As with totem poles and murals, the designs in each blanket incorporate the crests and legends of the original owner for whom the blanket was woven. (Although they are called "blankets" by Westerners, they were always worn as ceremonial shawls by important chiefs—but the name "blanket" stuck.) When a blanket was given to another chief as a gift, the new owner not only received the item, he acquired some of the power and rights inherent in each crest shown in the blanket.

This blanket tells how a young man used the power of Eagle to capture whales and become ruler of the sea and his own tribe. The blanket is symmetrical about its central axis. Each half shows one side of the creatures represented. The left and right sides of Whale are shown top center, and those of Eagle are shown at the far right and left. The young man is shown below center. He has acquired Eagle's claws as well as his eyes. Because Eagle is endowed with special eyes that can see great distances as well as close up, he is thought to have many sets of eyes.

Paint on woven cloth, 53 inches by 84 inches.

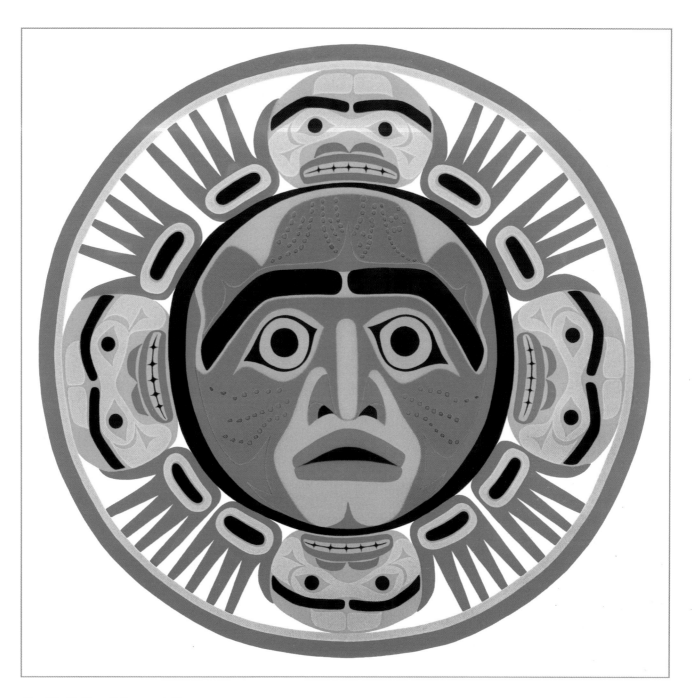

Fig. 36: Unity of Sun and Man

The sun was one of the more important gods of the Northwest Indians. The Indians believed in the power of animals and natural forces. They saw the sun's activities as being tightly interwoven with those of man. In this portrayal of the sun, four human faces, each with their hands held up beside their heads, face north, south, east and west. The eight hands together make up the rays of the sun. The faces and hands are those of tribal chiefs.

The painting was inspired by a Bella Coola Sun Mask first collected in 1897 by the anthropologist Boaz. It is now on display at the American Museum of Natural History in New York City.

Paint on canvas, 4 feet by 4 feet. Also available as a 30 inch by 30 inch serigraph.

SUPERNATURAL CREATURES

Fig. 37: Wild Woman of the Woods

Suska, the wild woman of the woods, has animal claws and the teeth of a wolf. She is shown here in skeletal form, a typical Indian form of rendering. What is also revealed by this x-ray view is that she is pregnant with child.

Paint on canvas, 4 feet by 6 feet. Also available as 30 inch by 40 inch serigraph.

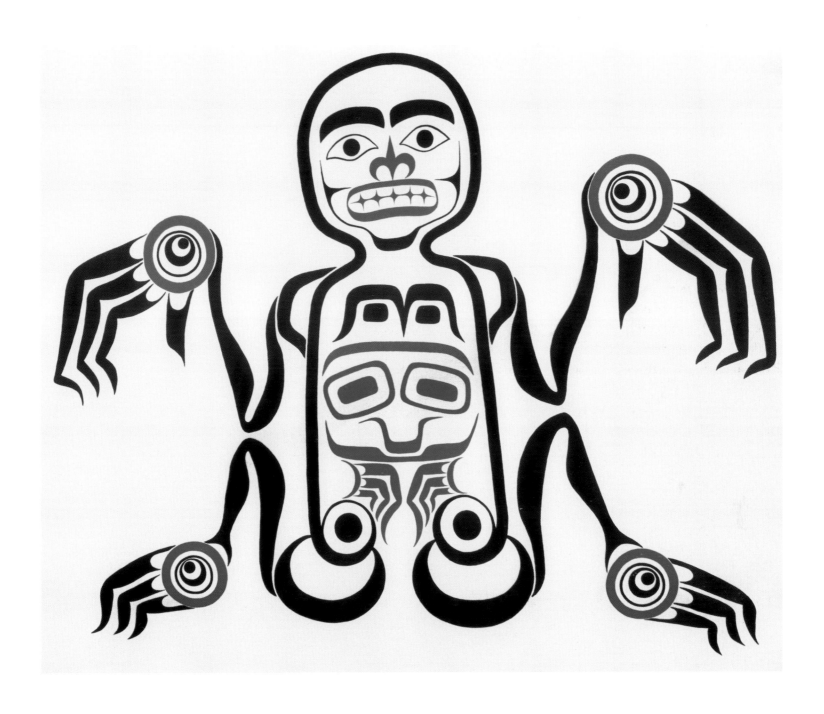

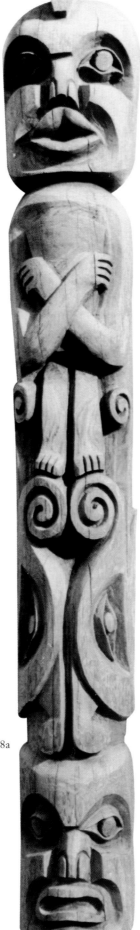

Fig. 38a

Fig. 38b

Figs. 38a, b, c: Sisiutl, the Two-headed Dragon

Sisiutl is one of the more complex of creatures revered by Northwest Indians. There are other supernatural monsters in Northwest Indian mythology, but Sisiutl appears most frequently in their art and in stories then do the others, and is often tagged onto stories and inserted in the art about other animals and people.

Described physically: Sisiutl consists of two snakes attached to a central human head. The human head has two horns on it, and each snake head sprouts one large horn on its head. Each snake head has a long tongue protruding from its mouth. The body of the snake is sometimes shown with claws, at which point it is more lizard than snake.

Sisiutl lives in the sea and can assume the shape of a fish. It sometimes becomes entangled in fishermen's nets, producing serious problems. To eat it or touch it is to ensure death, because one's joints become dislocated, and one's head is turned backwards. Sisiutl's blood, when it touches the skin, makes it hard as stone. Sisiutl is considered to be a helper of warriors and shamans, as it can bring power to those who are brave and know how to employ the supernatural. A belt of its skin gives magical powers. Its eyes, when used as sling stones, can kill whales. Its body, when one has no alternative, can be used as a canoe.

For the ordinary human being, just to set eyes on this serpent is unlucky, but to possess a piece of the creature's body or skin brings luck in fishing and hunting. Bathing a child in Sisiutl blood will turn the child into stone. Thunderbird is said to live off Sisiutls.

Sisiutl is sometimes portrayed stretched out horizontally from one snake head to snake head, with the human head placed in the center. Sometimes Sisiutl is shown folded in half, with the two snake heads placed close together, and the human head placed opposite.

I have carved two Sisiutls and painted two.

Figs. 38a, b, c: Two Sisiutl House Posts

These are carvings of male and female tribal leaders each sitting on their own Sisiutls. These are a pair of house posts that will stand at the same end of a chief's house and support the main beams. Here Sisiutl is folded in half, so that the human head is at the base of each post. Each tribal leader is shown holding a copper shield. Wood, 20 inches by 96 inches.

Fig. 39

Fig. 39: Sisiutl is shown here with its body stretched out horizontally, and its two serpent heads located at opposite ends from its central human head. The painting is based on a 19th century Kwakiutl wooden mask used in ceremonies. The mask was carried in front of the face. The two serpent portions are hinged on the central head and were waved back and forth during the dance. Paint on canvas, 18 inches by 48 inches.

Fig. 40: This is a painting of Sisiutl on a wood object I have already introduced in another figure: the front face of the Funerary Box (Fig. 30). The close up of it shows Sisiutl wrapped around the face of the Hawk that Swallows its Own Beak. Sisiutl here is shown to have claws on the snake portions of its body. The human head at its center is also mirrored in both snake parts.

Fig. 40